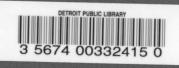

Drawing and Painting the Natural Environment

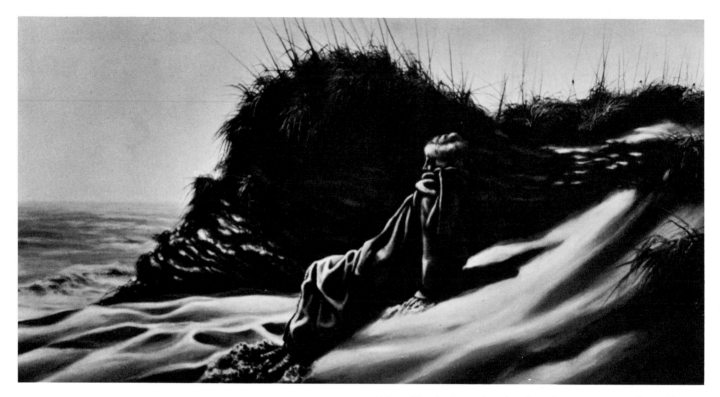

*Winter Watcher* by author. Acrylic polymer on canvas. Owned by Mr. and Mrs. Jerry White. Observing and experiencing the natural environment is an important part of a genuine interpretation.

# Drawing and Painting the Natural Environment

**Barclay Sheaks**    Associate Professor of Art, Virginia Wesleyan College

Distributed by
STERLING PUBLISHING CO., INC.
419 Park Avenue South
New York, N. Y. 10016

Davis Publications, Inc.  Worcester, Massachusetts

To Jeanie Sheaks, my mother, whose deep interest in
the natural environment and love for it led me to that
same understanding; and whose sacrifice and encourage-
ment made it possible for art to be my life's endeavor,
this book is lovingly dedicated.

Copyright 1974
Davis Publications, Inc.
Worcester, Massachusetts, U.S.A.

Printed in the United States of America
Library of Congress Catalog Card Number: 74-78390
ISBN 0-87192-060-3

Printing: Davis Press, Inc.
Type: Univers set by Davis Press, Inc.
Design: Jane Pitts
Consulting Editors: George F. Horn, Sarita R. Rainey

10    9    8    7    6    5    4    3    2    1

# Contents

# Acknowledgments

The attitudes of certain persons with whom I was associated during my youthful and formative years played a major part in directing my interests toward the natural environment. The appreciation and enjoyment of nature was a necessary part of life for them. Eugene and Lilly Rice, my maternal grandparents; Helen and Ralph Bingham, and Jeanie Sheaks, to whom this book is dedicated, all played important roles in my education in art and nature. John Bushong, a Shenandoah Valley farmer, shared with me many of his insights into nature and opened my eyes to its beauty through his special gift of awareness.

There are many who are deserving of recognition for their active contributions to this book, especially my wife Edna, who encouraged and inspired me. Thanks to Dr. Anderson Orr, who acted as the first reader and provided helpful comments, insight and advice.

Marc Moon and Allan Jones have been most considerate and generous with their time and talents. They willingly and capably rendered a number of specific illustrations. Ken Bowen's photographs bring fresh images to this book. The Virginia Museum in Richmond was most cooperative and a special word of thanks is due Lisa Hummel of their staff, who aided my search for appropriate historical examples. To Bill Radcliffe, photographer and friend, I am very appreciative for his attention and devotion to uncompromising quality. Bill Jennison of the publisher's staff was most helpful and provided encouragement.

Without an efficient typist, this whole endeavor would have been painfully prolonged. For her endeavors I am most grateful to Janet Case.

I am particularly indebted to all the friends, teachers, artists and students, present and past, whose contributions made this book possible.

*Contributing Artists, Photographers, and Students*

Thelma Akers, Betty Anglin, Dorothy Arey, Florence Buchannan, Arthur Biehl, Cameron Bone-Kemper, Ken Bowen, Skip Boyer, Joyce Brewster, Gerald F. Brommer, Gayle Brown, Dixie Browning, Pam Dubni, Cheryl Eberhart, Mary Evans, Jack Fretwell, Loraine Fink, Bunny Freeman, Ben Garrett, Cynthia Haack, Ann Halliday, Mary Ann Haines, Mary Ann Harman, Kenneth Harris, Jim Hill, and

Chip Jenkins, David Jett, Cornelia Justice, Allan Jones, Herb Jones, Clarence E. Kincaid, James Kirby, Terry Klopfenstein, Larry Knight, Laurina Ledwitch, Edna Love, Robert Marsh, John Matheson, C. McAlpin, Jackie Merritt, Elmer Midgette, Betty Zoe Miller, Vance Mitchell, Mary Lou Moon, Marc Moon, Joseph R. Morton, Harry Noland, Virginia Peck, Richard Porter, Bob Price, and

Lillian Rosenthal, Mary Schinnerer, Charles Sibley, Jude Sibley, Valfred Thelin, Thomas Thorne, Frank Trozzo, Robert Vick, Luranah Woody, Leona Woody, and Russell O. Woody, Jr.

# Introduction

Man has always been interested in and curious about the natural environment. He has used the graphic arts as one vehicle for examining and interpreting it. These expressions soon became highly organized systems of viewing nature, undergoing many changes of appearance, employing a variety of techniques and styles and materials and media.

As the man-made environment encroaches upon the natural one, our attitudes about the natural environment and our relationship with it change. The contemporary artist has, through historical awareness, the proven and traditional means for interpreting new ideas and materials. He has also developed new and meaningful methods for expressing these feelings as a personal statement.

This book, with its exercises in seeing and organizing, coordinated with experiments in various techniques, will help the artist-student to evolve new interpretations of and deeper insights into the natural environment and to develop a personal, articulate form of expression.

This book is intended to be versatile in its application. The way it is used will depend upon the background of the reader, his experiences and interests. The following may serve as a guide to help you investigate the natural environment more profitably:

For those familiar with the basic skills of painting and drawing but uninitiated in the methods of traditional land and seascape painting or in the processes of creating abstractions from nature, this book can serve as a step-by-step guide.

For the accomplished painter who has not investigated the areas introduced here, it can serve as a starting point for adapting already developed skills and methods to explore a new subject from various points of view. The illustrations offered and the suggested exercises will offer new insights and approaches.

This book may also serve as a guide for the appreciation of traditional land or seascape painting and as an introduction to a deeper awareness and enjoyment of the natural environment itself, as seen in terms of basic design and abstracted images.

The teacher will find many techniques explained as well as suggested exercises for both observing and painting or drawing. Basic design and composition and approaches to tone and color as related to traditional land and seascape painting are covered. Methods for abstracting from nature are also introduced.

*Figure in a Landscape* by Charles Sibley. Oil on canvas. Courtesy of Imperial Gallery, Virginia Beach. Developing a personal feeling for the natural environment is necessary before a unique statement can be made through one's paintings. Years of firsthand observation and hard work have contributed toward the deeply personal interpretations of this sensitive and mature artist.

## Chapter One

# Preparation for Drawing and Painting the Natural Environment

Because experienced landscape painters have developed their personal procedures and problem-solving approaches, they have forgotten the very real and frustrating experience of not knowing how to go about starting a simple landscape painting. Artists who are experienced in other subject matters often adapt to landscape painting more easily by applying and utilizing their already successful working habits and organizational methods.

Frequently, however, even artists who are accomplished in painting portraits, still life arrangements and abstractions experience a sense of inadequacy when faced with the task of interpreting nature; to "take it on" with all of its complexities and vastness. This chapter will deal with questions concerning both the philosophical and physical aspects of various topics that relate to organizing one's thoughts about painting landscapes or interpreting the natural environment. It will also examine approaches to organizing working procedures and materials.

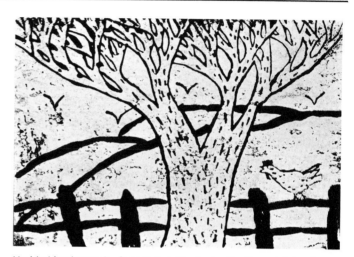

Untitled landscape by Pam Dubni. Grade six, Knollwood School, Piscataway School System, New Jersey. Children are keen observers in their own way. This often results in expressions that are not only uniquely personal statements but well organized works of art. This charming piece is a good example.

### Use What You Already Know

Many individuals have had valuable experience in interpreting the natural environment. This can aid greatly in putting their thoughts into ideas and forms suitable for landscape painting. In most instances it is just a matter of shifting gears in the way you think. If you can paint apples, bottles and fruit, you can paint hills, rocks and water, for they are similar in form and texture. If you can render convincing facial features—hair, eyes, etc., you can paint grass, trees and shoreline. If you can paint a background, you can paint a sky. If you can paint a good abstract painting, you are familiar with composition and design problems that deal with color, line, tone, texture, form and space; you will be using recognizable instead of non-recognizable objects.

The artist-student with limited problem-solving experience in drawing and painting may intuitively have useful skills in seeing, observing and feeling. Most individuals who are interested in the natural environment enjoy looking at nature and observing it; they confidently describe it to others and take pleasure in sharing their feelings. This is what the landscape painter is doing with paint: feeling, observing, describing and interpreting.

## Use the Familiar But Search for the New

Using one's prior knowledge and experiences in related fields can be most valuable in solving art problems. However, trying to use one formula to solve all problems can have unfortunate consequences both to the individual and to the problems attempted. Accomplished artists who have developed workable approaches, ideas and methods which achieve successful results often become blind to other ideas and techniques of pictorial problem solving that could enrich their work.

Explore the relationships between what you know and have experienced and its application to the task at hand. Be prepared to see new relationships, to try new approaches, experience new techniques and to innovate.

## Don't be Intimidated by the Rules

Rules are useful as the starting point to problem solving. They are proven methods that will work for certain things. They can serve as guidelines for confidence until other avenues can be developed. For some individuals, undue emphasis upon rules and organizational procedures dampens the enthusiasm and makes the creative process too cold and analytical. These people find it easier to work intuitively, and then, when well into the project, stop to evaluate. Then they can plunge into it again with a new sense of direction. For that person, this book becomes a reference guide for evaluation or a springboard to stimulation.

For the individual who prefers a logical, step-by-step approach, these methods will serve as a building guide or work plan.

## Developing a Working Philosophy

It is important to develop a working philosophy about your subject in landscape painting. A sense of direction and a confident state of mind can do much toward facilitating success. Inspiration has an important place in creatively solving problems. Inspiration can be thought of as the desire to create, the urge to do, the need to express. Great inspiration with little know-how can result in unfortunate results, full of frustration. A little knowledge, a skill, or an approach that can be used as a starting point will give some form to this inspiration. Some knowledge and a successful experience, no matter how small, lead to the confidence necessary to go further.

Do the best you can, use all that you know and feel, and then evaluate what you have done. Work to learn and learn by working; evaluate and then move along to another problem. You cannot learn everything in one try.

This brings us to the role of discipline in the working philosophy. Many individuals stop working when success is not easily achieved. There is a vast difference between learning about something and learning to do it. The gap between the image of what is expected and what is achieved is one that many would-be artists never cross over. One must learn to work into inspiration as well as from inspiration. Take each problem as it comes, find joy in the actual work itself and the eventual goal will take care of itself.

Opposite: *Corn* by Cheryl Eberhart. Grade six, Randolphville School, Piscataway School System, New Jersey. This study of corn by a young artist describes with surprising accuracy many characteristics of the subject and, at the same time, creates a striking visual pattern.

Second part of a pair of six fold screens, Baitsu, 1783-1856, Japanese. Courtesy of the Virginia Museum. A philosophy of living evolved from a close relationship with nature, combined with disciplined artistic skill, was a necessary part of this artist's sensitive study of a tree.

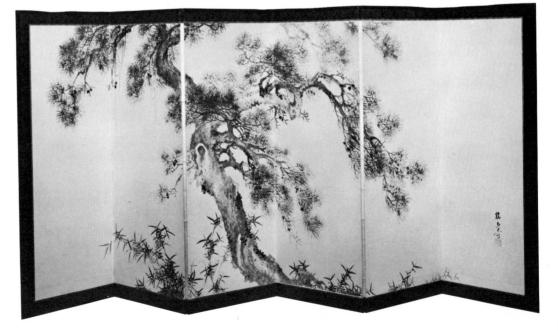

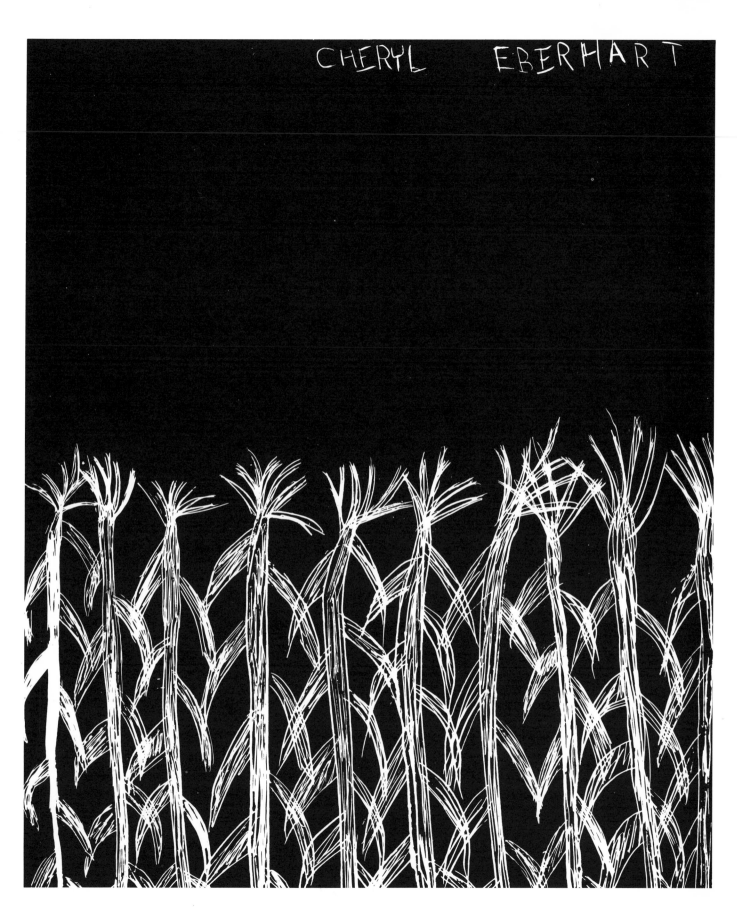

## The Value in Learning to See and Observe

Interpreting nature with any competency requires the total vision of understanding and seeing with meaning. It means knowing how things are constructed, how they work, the relationship of cause and effect and the hidden relationship between things. Even to suggest an object impressionistically in a painting requires an understanding of it.

Grass, for example, is a common, but major, element in many landscape paintings. There are many ways of seeing it, each playing an important part in the appearance of the completed work. There are many botanical specimens of grass. Examine how the blades are formed and grow from the stem; note the importance of its root structure; seeing how it grows into a clump—holds the earth, what happens to its color and appearance in all stages of growth, what happens when it is subjected to the natural forces of wind and weather. Certainly grass can be

represented without this knowledge, but how much more authentic even the suggestive brush stroke becomes when it is applied with these understandings.

Depending upon how it is used in the design, grass is not only a biological reality but an artistic element which can be depicted in a way that emphasizes its linear quality, its shape or form as a part of a pattern, or its texture and color.

Acquiring this kind of vision requires a new attention to and concentration upon visual aspects of nature different from those required in our usual daily experiences. Discovering this vision, however, can add vital enrichment to your daily life and give feeling and authenticity to your art, no matter what style, motif or technique you select for your interpretation. This book will suggest many exercises in seeing and observing in relationship to the various aspects of the text. Some exercises combine drawing and painting with observing and some are exercises in observation, thinking and feeling.

## Working on Location or in the Studio

Should I take all of my equipment and set it up at the spot I have chosen for my painting, or can I make a few sketches on location and then return to the studio for the actual painting?

Teachers and painters have diverse opinions on this question. Consider the advantages of both and decide which approach best suits your own needs or situation.

Working on Location—Advantages

1. The reality of the experience of being there is inspiring. This can give your work the authenticity of a firsthand experience, for which there is no substitute.

2. For the student-artist, the organization required to get the proper equipment set up, to eliminate the cumbersome and unnecessary, to simplify, innovate and make do in order to work adequately is a learning experience that no other can duplicate.

3. There is historic precedent for going to the natural environment to create. The history of landscape painting includes many artists who sincerely felt that this was a necessary element to be practiced diligently.

The Disadvantages

1. It can be very inconvenient. Bad weather, uncomfortable situations and lack of free time to go to suitable locations hamper many artists.

2. It attracts attention and draws curious onlookers. Not all places of pictorial interest are lonely and remote; in fact, many choice spots are quite public. Nothing draws a crowd like an artist or two sketching or painting. Comments, questions and helpful advice from spectators of all ages can often prove quite distracting.

Working in the Studio—Advantages

1. Work can proceed at any time and in all types of weather. Either inside or out, a permanent set-up with equipment, materials and working space saves time for painting that would be used getting ready for on location trips.

2. You do not have to change working habits and equipment, or substitute and adapt materials and space.

3. You are frequently more comfortable and have fewer distractions and hazards. Many artists have found that their work improved when they were not freezing from the cold or burning from the heat and did not have to fight the wind, hostile insects, animals, difficult terrain and curious spectators.

Opposite: *Dune Grass* by author. Acrylic polymer on Upson board. Only a small section of the natural environment can offer pictorial possibilities.

4. You can more easily dictate or control the picture. The powerful effect of being at the spot when creating can frequently cause the artist to see too much, or to feel too strongly about every detail. He will put in objects which should be left out, emphasize too many areas which should be only suggested, and feel inhibited about moving things about in the composition for the betterment of the completed work.

It is much easier for some individuals to choose and eliminate, thus controlling the total picture when not on location. "Putting something in just because it was there" has probably ruined more landscape paintings than any other single factor.

The Disadvantages

1. Working isolated from the scene and location can lead to a lack of authenticity and understanding of the subject matter, resulting in sterility and lack of feeling.

## The Proper Approach for You

Most artists develop a modified approach which is dictated by their personality, artistic objectives, lifestyle and situation. No matter how one interprets nature or which motif, style or technique is used, if nature is the starting point or stimulus, it follows that the individual must have some firsthand personal encounter with his subject.

Many landscape painters spend a lot of time in the field getting ideas and a feeling for the subject—doing sketches of various kinds, making color notations, perhaps taking a few photographs. They then return to the studio to create the finished project. Suggestions for exercises in observing and working on location and suggestions for several painting sessions on the spot will be made. After you have tried the various exercises and approaches, it will be much easier to select those most suitable for your needs and situation.

## Working from Photographs—A Hindrance or a Help

There are as many diverse opinions held by artists and teachers on this subject as there are to paint on location or in the studio.

The Advantages of Working from Photographs

1. It is a quick, time-saving and convenient way of recording subjects, locations, objects, scenes, textures, forms and other information pertinent to your particular working objectives.

2. The camera can be a useful aid in learning to compose on the spot. The process of selecting, eliminating and making decisions as to viewpoint, eye level, etc., if knowingly and intelligently used, can greatly improve one's ability to compose pictorially.

Artist Marc Moon makes intelligent use of photographs as idea resource or subject matter material for some of his paintings. The illustration above is a photograph taken on location. The illustration opposite is the completed painting done from the photograph. Notice the difference between the two pictures. Notice how Moon has spread out the composition in the painting and simplified the subject, eliminating many objects and details in the process. This allows the viewer's eyes to move easily throughout the picture and to concentrate without distraction upon the subjects singled out by the artist as points of interest.

The Disadvantages

1. Probably the biggest disadvantage, and the one feared by most artist-teachers, is that often the photographic image is so influential, the artist falls into the habit of being a slave to it. He may indiscriminately copy the color, tonal, compositional and perspective flaws and distortions recorded explicitly by the cold lens of the camera.

2. Working directly from photographs can keep one from learning to observe. When an object is sketched or drawn from reality, one has to carefully examine and understand the subject before drawing it. Drawing it also helps one remember. The photograph gives one viewpoint. When working directly from nature the subject is seen in the reality of three dimension as opposed to the two-dimensional illusion of the photograph.

3. Relying mainly on photographic material as subjects for painting does not give the student-artist the confidence needed to compose and complete, from start to finish, a painting inspired by an idea or brief visual impression. Instead, he must search for a picture or photograph which might relate only suggestively or not at all to the original idea and feelings. This often leads to a vicarious experiencing of nature, seriously hampering genuine interpretation or representation.

## A Logical Approach to the Use of Photographs

It should be quite obvious that the camera can be a most valuable aid to any artist seeking to record, interpret or express visual feelings about nature through drawing and painting. The camera can be used to advantage in studying texture, form, objects and composition. It is also a great aid in the study of moving objects, as well as facilitating the study of certain small objects and areas by isolating and enlarging them.

Thus, the camera offers many advantages in studying the environment when preparing to paint. One should be aware, also, that one's background of experiences determines a great part of how valuable and in what manner photographs will be used. The experienced painter and the informed beginner making intelligent, selective and advantageous use of photographs will find it both useful and helpful as one of many possible means toward the creative end of interpretation.

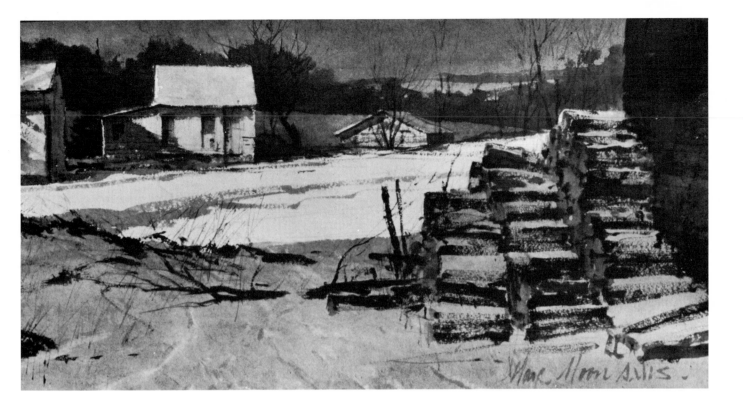

The illustration below is a photograph taken on location. On the right is the completed painting done from the photograph. In creating this striking object-dominated composition, artist Moon has eliminated the roof top visible behind the silo. For the sake of interest he has attached a beam and pully to the silo and added a gliding gull as a contrasting relief to the strong architectural form.

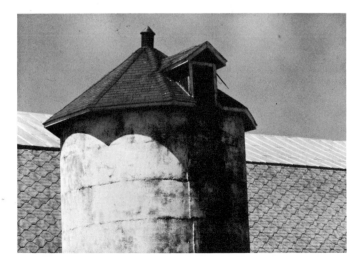

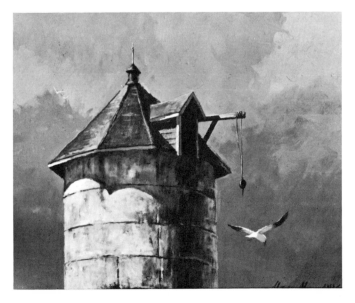

## Finding a Studio or Work Space

The amount and size of space and equipment will be dictated by the size of the paintings and drawings, the medium used and the equipment necessary for executing the works. All studios or work areas, regardless of size, need the following minimum characteristics:

1. A well-lighted area where the artist can work comfortably without being cramped or crowded. Lights can be natural daylight, incandescent or fluorescent. If daylight fluorescent tubes are used, the colors will appear more natural.

2. Adequate equipment and supplies. This means easels, worktables, paints, pencils, brushes, canvas, paper, etc.

3. Storage space for equipment, supplies and work in progress. Having a space to leave work-in-progress is an advantage because it can be worked on conveniently at any time. If this kind of space is not available, then safe storage space for work-in-progress, equipment and supplies is essential.

4. Easy access to a sink or a water supply. This is very important if paints are to be used since the brushes will need cleaning. It is essential if water color is your choice of media. If no sink is handy, a bucket or tub can be used.

Don't let the lack of a large working space stop you from working. You may have to clear a space and set it up when you want to work, store your equipment in unlikely places when you finish, or scale down the size of your pictures, equipment and supplies, but if you really want to work you can and will find a place.

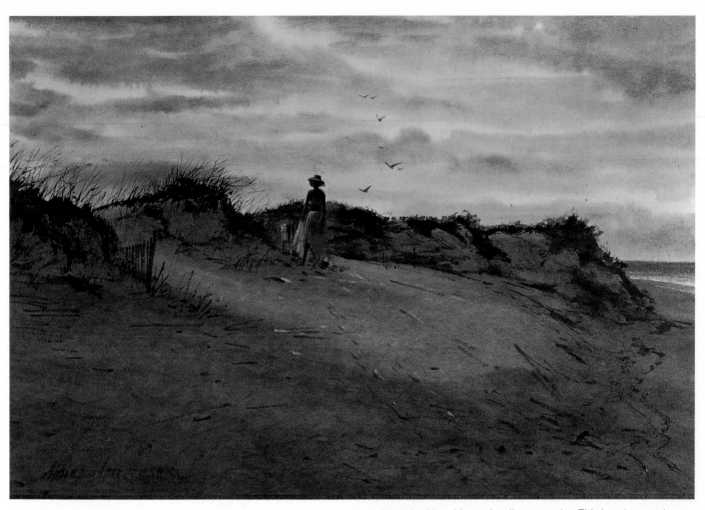

*Solitude* by Marc Moon. Acrylic watercolor. This low-key, cool-dominated beach study uses color effectively to set the mood of the picture. The single figure adds a feeling of calmness and warmth for the focal point. Shadows and dune contours allow the eye to move quietly through the composition. The technically skilled Moon makes rich use of watercolor while at the same time practicing restraint for the sake of mood.

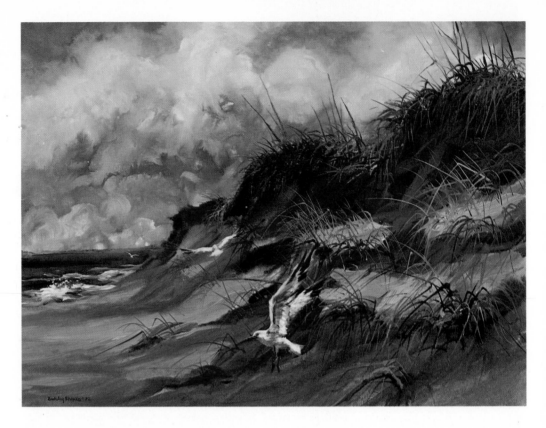

*Storm Warning* by author.
Acrylic polymer on Upson board.
Courtesy of the Seaside Gallery,
Nags Head, North Carolina. The
diagonal thrusts of the dunes,
swirling movements of the clouds
and use of subdued color set the
mood of this picture. To em-
phasize this feeling, the shadows
and dune shapes are represented
as being angular and sharp rather
than smooth and free-flowing.

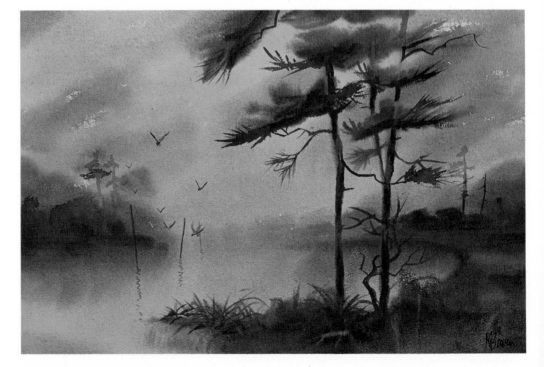

*Evening* by Ken Bowen. Water-
color on paper. The sharp con-
trast between the crispness of the
trees and the soft, blended tones
of the background gives this
romantic water scene a feeling of
depth. At the same time the
dominant horizontal and vertical
movements of the composition
create an effect of calmness and
placidity.

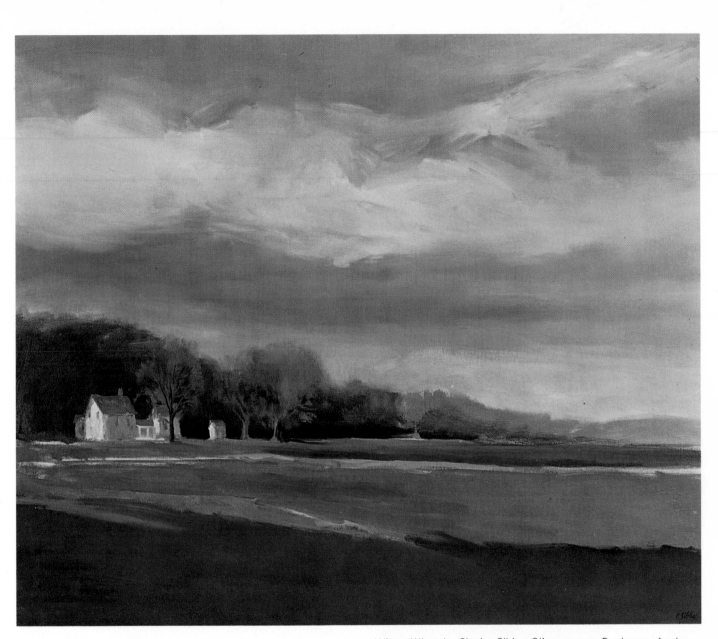

*Winter Wheat* by Charles Sibley. Oil on canvas. Freshness of color, a love of paint and a feeling for open space characterize this strong landscape. This cool-dominated picture is accented by the spots of warmth in the earth and roof tops. The feeling of winter sunshine is suggested by coolly illuminating the buildings and contrasting them against a dark background. A composition of horizontal movements carries the eye back and forth always returning to the focal point of the building.

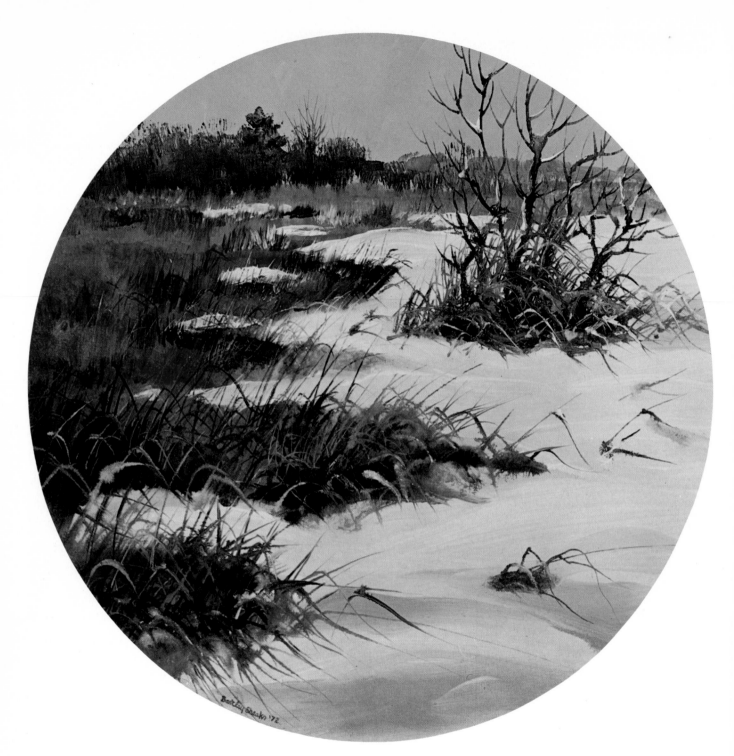

*Winter Marsh* by author. Acrylic polymer on Upson board. The composition of this circular painting is dominated by a line of 'S' curves which lead the eye in a meandering fashion from the foreground to the background. The rich color of the marsh grass is warmly accented to contrast with the coolness of the snow and sky, both simply represented to act as relief or visual rest areas from the textural and linear activity of the grass and trees.

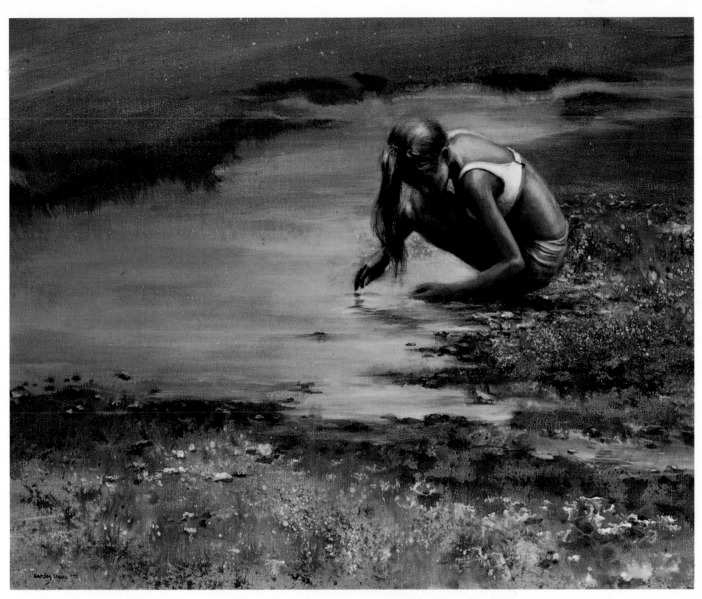

*Tide Pool* by author. Acrylic polymer on canvas. The warm domination of the sand and sun reddened skin are accented by the subdued coolness of the water and the clothing of the figure. The depiction of the scene, as if viewed from above, directs the concentration to the beach textures and the figure caught in an intimate moment. The total effect implies the environment of the seashore.

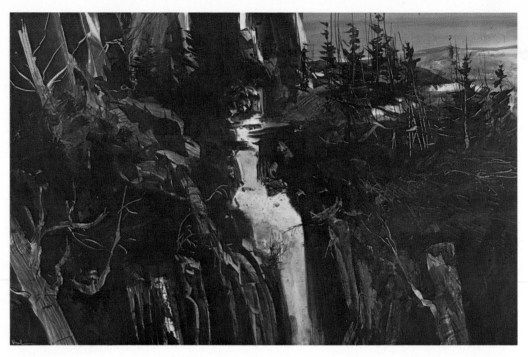

*Colonnade Falls* by Valfred Thelin. Watercolor. This striking composition captures the authentic mood and ruggedness of a particular location. The dark-dominated tone quality is offset by the jagged white shape of the waterfall. The diagonal thrusting movements of the rocks and trees convey successfully a feeling of action and power, dramatically interpreting the forces of nature.

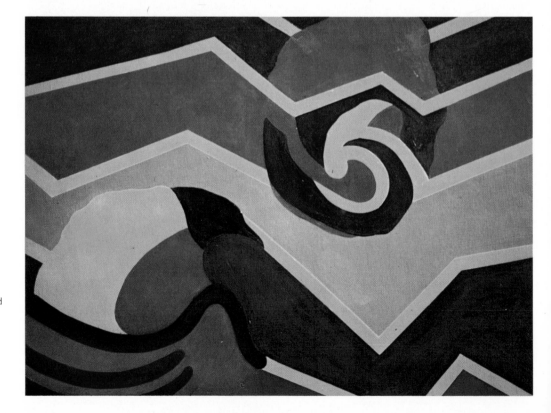

Untitled abstraction from nature by Dorothy Arey, student, Virginia Wesleyan College. Acrylic polymer on Masonite panel. This strong, inventive painting was abstracted directly from nature, using a textural nature rubbing of a wood grain as a basis for the design. The primary colors of red, yellow and blue were used extensively to give contrast, color-power and strength.

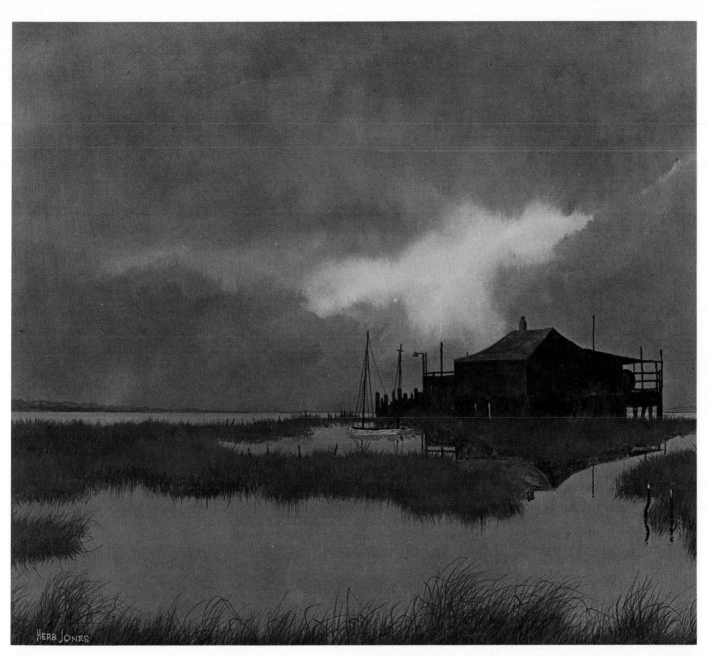

*Marsh Castle* by Herb Jones. Watercolor. Skill in handling the medium and a knowledge of its characteristics enable artist Jones to capture a mood as well as depict authentic realism. This cool-dominated picture utilizes the color of the grass and the light in the sky as warm accents effectively contrasted against the coolness of the sky and water.

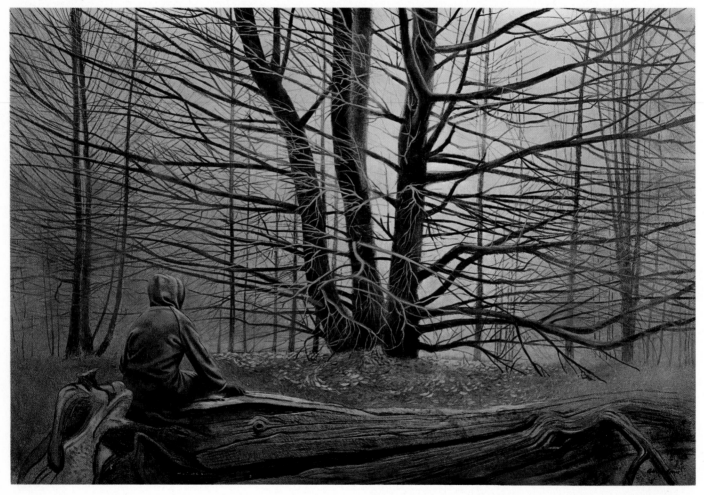

*Rain in the Forest* by Allan Jones. Acrylic on Masonite panel. A sharpness of perception and a love for the natural environment enabled this gifted artist to make a strong poetic statement. The contrast between the warm and cool colors creates an unusual amount of depth in a composition that moves very quickly from the foreground to the background. The clarity and sharpness of contour call attention to the seated figure and heighten the mood of loneliness and solitude.

# Chapter Two

# Beginning to Draw and Paint

### Sketching—Why, What and How

Sketching and drawing are very much a part of landscape painting. They help one to develop skills in seeing and remembering, as well as vastly improving competence and accuracy, qualities so necessary for a successful final creative product.

As important as sketching and drawing studies may be, the random indulgence in out-of-door sketching, without purpose or real direction, usually leads to frustration and disappointment. For an artist to benefit from a sketching trip, he should determine the reasons for going and the kinds of sketching most useful for his purpose.

### Draw for a Purpose

One should forget about producing Art with a capital 'A' and emphasize the pragmatic and the practical. Get the most from these drawings with the least effort in the shortest amount of time; concentrate on the practical end in your sketching. You will probably find that the results are not only useful but also aesthetically valuable and uniquely original. Most certainly they will be yours.

The artist's main purpose in sketching on location is to gather the necessary information to enable him to paint a complete picture in the studio. Doing so will enable him to gain an understanding and feel for the particular location.

### Kinds of Sketches

There are numerous kinds of sketches which could be used to advantage for gathering the information needed for landscapes. Two are particularly worthy of attention because of their practical uses. They are object studies and composition studies. An understanding of them, plus skill in their execution, will do much toward making the total work of art easier to achieve and more satisfactory.

**Object Studies.** A collection of object studies of various subjects can be used repeatedly in most types of interpretations and styles. They are enjoyable to do and, in a surprisingly short time, the industrious student-artist can build both drawing skills and a library of resource material.

In brief, an object study sketch is a rather careful, graphic examination of a single object, part of an object, or the whole or part of an interrelated group of objects.

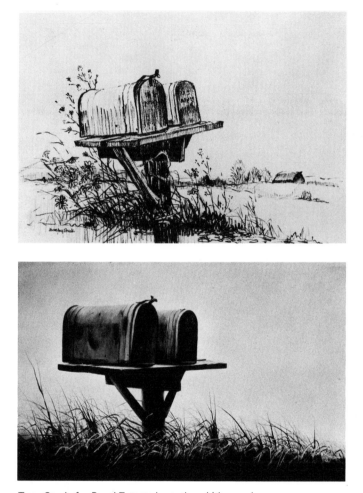

Top: *Study for Rural Totems* by author. Lithograph crayon on paper. This sketch, done from memory, was inspired by a subject observed on a trip to the Virginia highlands.

*Rural Totem* by author. Acrylic polymer on stretched canvas. This painting used the sketch "Study For Rutal Totem" as a guide. Much of the detail in the sketch was eliminated in the completed painting. The details seemed necessary in the sketch, but detracted from the subject when the idea was changed in this particular painting.

Left: *Trees on a Cove* by Chip Jenkins. Student, York County High School, Yorktown, Virginia. Ink and wash on paper. This media can be an excellent one for sketching out-of-doors if the artist has developed some skill in using the technique.

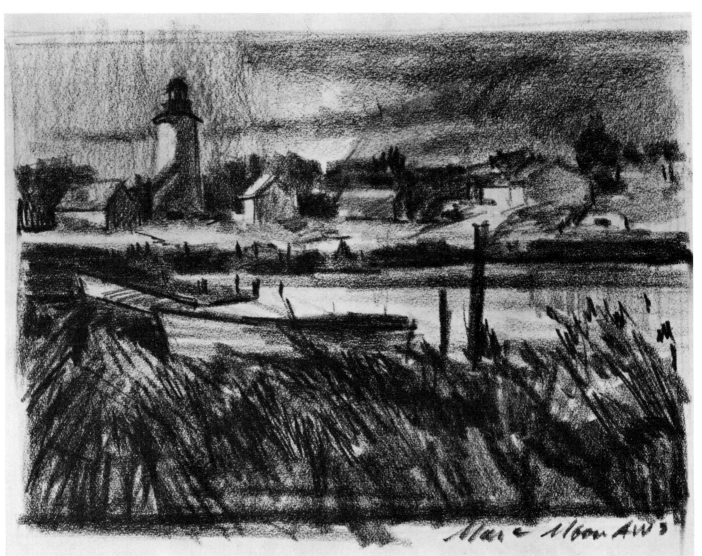

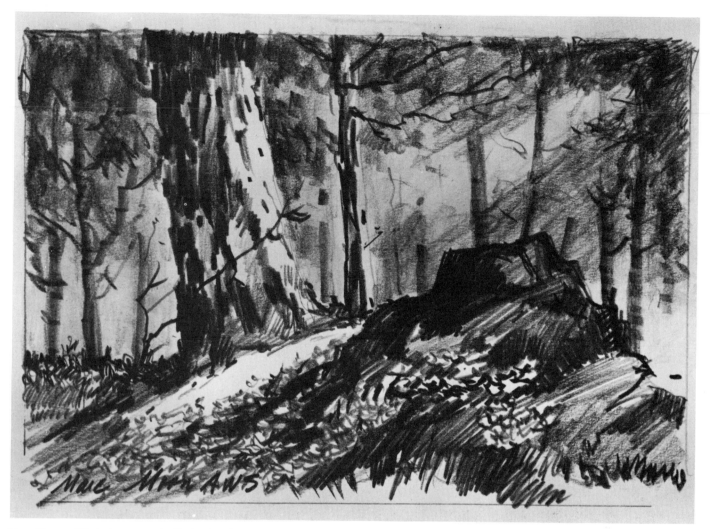

Marc Moon, skilled observer and gifted artist, does many pencil
sketches (opposite and above) on location and uses them as guides
for finished paintings executed in the studio.

Left: *Object Studies* by Mary Ann Haines, student, Virginia Wesleyan College. Object studies can be simple descriptive pencil drawings like these.

Below: Allan Jones, artist and gifted draftsman, enjoys doing meticulous object studies. He uses ink and brush in a dry-brush technique on illustration board. Many of his favorite subjects are natural objects which have been washed up on the beach by the tides or worn by exposure to the forces of nature.

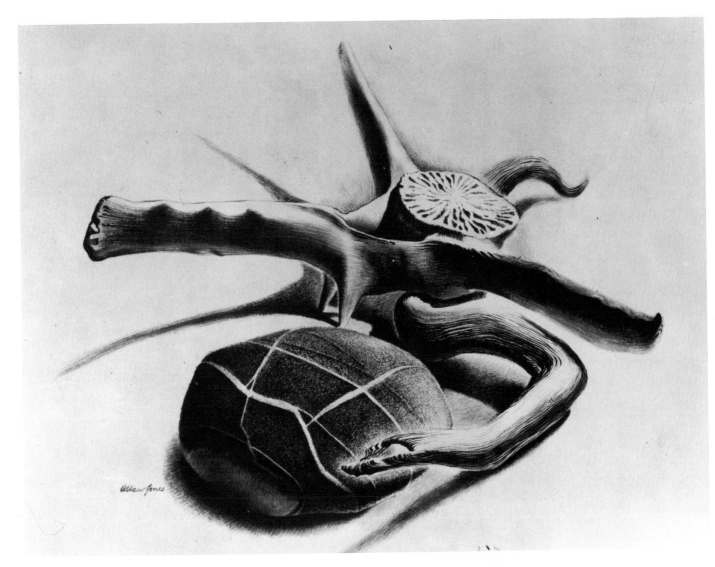

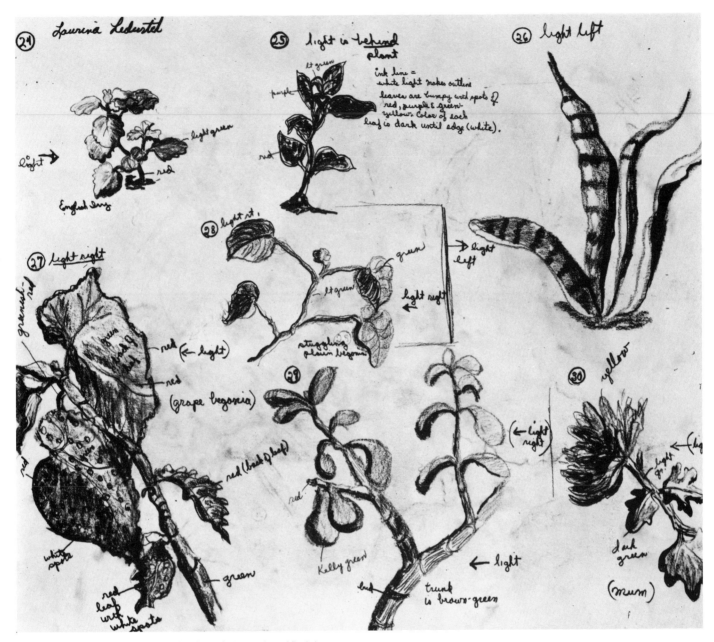

*Page from a Sketch Book* by Laurina Ledwitch, student, Virginia Wesleyan College. Object studies in pencil.

Depending upon the location, subjects could be natural objects such as an individual tree, parts of or groups of trees, various kinds of foliage, and interesting or unique rocks or similar mineral forms, seed pods, clumps or even blades of grass, birds, animals, seashells, etc. Other possibilities include man-made objects such as houses, barns, boathouses, boats, machinery and any object of suitable interest to be included in the work you might wish to paint.

Select materials which are easy for you to use and which require no cumbersome equipment. A sketchbook and pencil are convenient to carry. The paper's surface should be smooth to slightly pebbled, with no more than a slight tooth. A medium soft pencil (No. 2) would be a good selection. Some artists successfully use charcoal or colored chalks, as well as felt-tipped pens or Magic-Marker type pens. Any of these drawing tools may be used by themselves or combined with water color, ink-washes or other media and materials.

These object studies must be drawn in such a manner and with enough detail to be useful references when reproducing the object in your painting. In most instances, there should be no need to refer to the original object to complete the work.

1. Work fast; don't waste time by drawing duplicated parts or sections of objects. Finish one completely and rough sketch the locations of the others. Since they are all alike, the completed one will be enough to remind you how the others will look. For example, in a house with all the windows alike, sketch in one completely and rough sketch the location of the remaining ones.

Similarly, the study of a tree need not include every leaf. It will be enough to sketch its structure, the shape and location of its foliage, a small close-up of how that foliage looks in detail, how it is attached to the twigs and branches and some detail of the bark.

2. Don't get involved in drawing background details with the objects. Backgrounds can take up time which at this stage could better be used on further object or composition studies.

3. Use only the lines necessary to draw the object adequately. Use shadows and tones to achieve form. Make the structure of the object explain itself. Don't waste time with tricky and clever renderings with flashy pencil strokes that might appeal to the eye but do nothing to clarify the object studied.

4. In drawing, select a view which tells the most about the subject. An angle which describes its shape, form and character, its structure and identifying characteristics would be best for the "object study" drawing. A little practice in looking will provide the confidence and skill needed to select appropriate angles for viewing. A sales merchandise catalog will give an idea of how to select a descriptive view of an object.

Left: *Page from a Sketchbook* by Bunny Freeman, student, Chesapeake Bay Art Association. Object studies in pencil.

Right: *Totem* by Allan Jones. Brush and ink. Owned by Edna Parks. This arrangement of rounded stones topped by a piece of weathered wood illustrates how a simple subject can become a dramatic picture when seen through the eye of this artist.

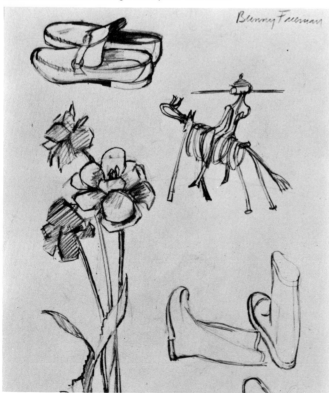

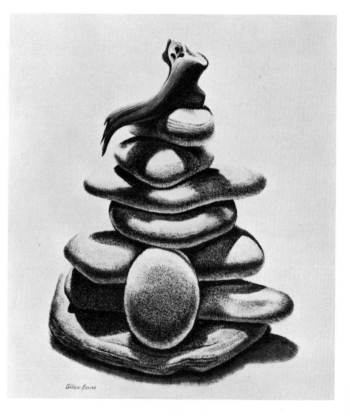

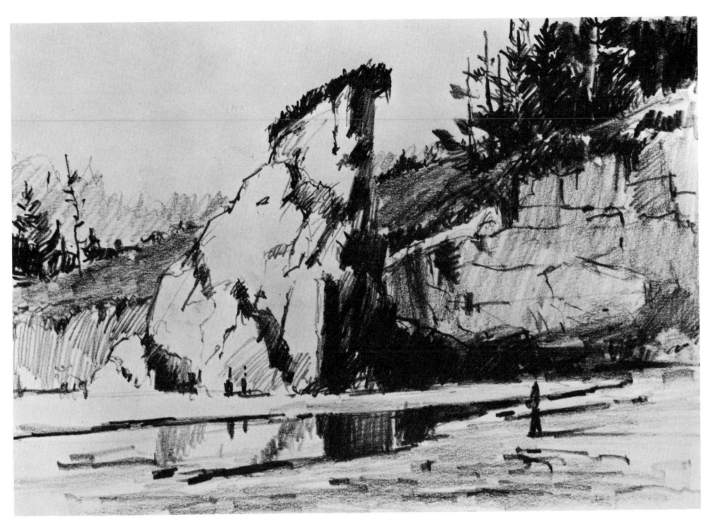

Above: *Rock, Oregon Coast* by Marc Moon. Pencil on paper. This composition sketch, quickly executed, is a good example of using lines and tones to advantage.

Below right: *Trees along the Ridge* by Charles Sibley. Acrylic polymer on canvas. Some artists enjoy using paint and brush for sketching. This beautiful composition study, executed on location, shows great skill in handling paint and in the ability to describe very quickly the contours of the ridges and the tree shapes with a minimum of detail.

**Composition Studies.** A composition sketch could be thought of most simply as a map to locate objects in a picture. In other words, it is a brief descriptive sketch of the basic divisions of space, such as sky, land, water, forests, etc. It contains simple representations of objects like houses, trees, boulders, boats, bridges, machinery, etc. and their locations.

These sketches should be done as quickly as possible with a minimum of detail. Written notations in or around the drawing may prove helpful as reminders of colors and textures or the feeling and mood of the scene. Sometimes these written reminders can add information and refresh the memory better than a detailed drawing.

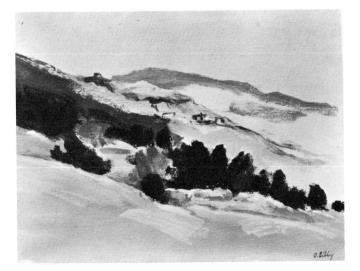

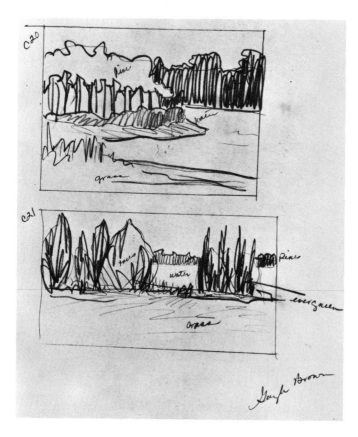

Below: *Composition Studies* by C. McAlpin, student, Chesapeake Bay Art Association. Black and white. Sketches like these, combined with brief, written color notations, help the artist recall the colors and the mood of the day as well as the composition.

Left: *Composition Studies* by Gayle Brown, student, Chesapeake Bay Art Association. Pencil on paper. Composition studies can be simple, quick sketches like these. The simple but skillfully employed outline quality not only indicates locations of objects and areas but describes their general shapes with surprising clarity.

Bottom: *Untitled* by Gerald F. Brommer. Pencil. The skill with which the composition has been arranged and the dramatic use of lights and darks make this a striking study.

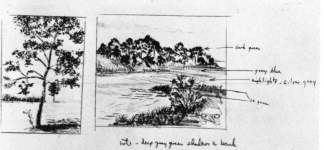

*Extensive Landscape with View of a Chateau* School of Jan Brueghel the Elder, early 17th Century Flemish. Courtesy of the Virginia Museum. The panoramic composition offers many possibilities for the expression of great depth. This picture uses a number of methods to achieve this, such as viewing the scene from above and clearly emphasizing the foreground and middle ground as well as the background.

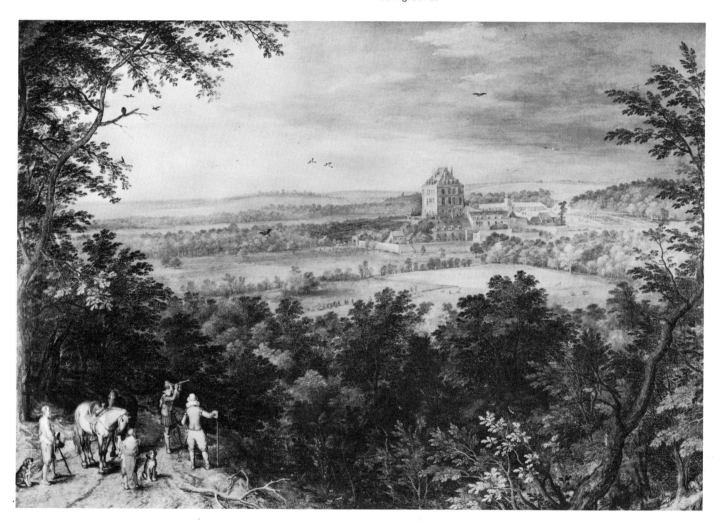

## Kinds of Compositions

Although there are an infinite variety of pictorial compositions and their combinations which present differences in appearance, most pictures will fall into three categories: panoramic, object dominated, and traditional. An understanding of these will not only give meaning to the ways you look at nature but will also give latitude and variety to your interpretations.

*Harbor Scene* by Cynthia Haack. Acrylic polymer on Masonite panel. By keeping the scale of the buildings and boat small and by placing grass in the lower left foreground, an unusual quality of depth is achieved in this sparkling water scene.

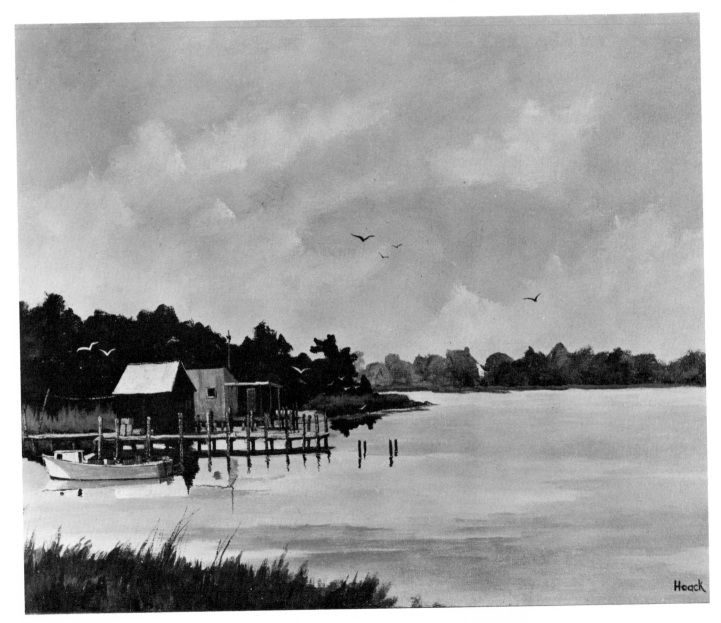

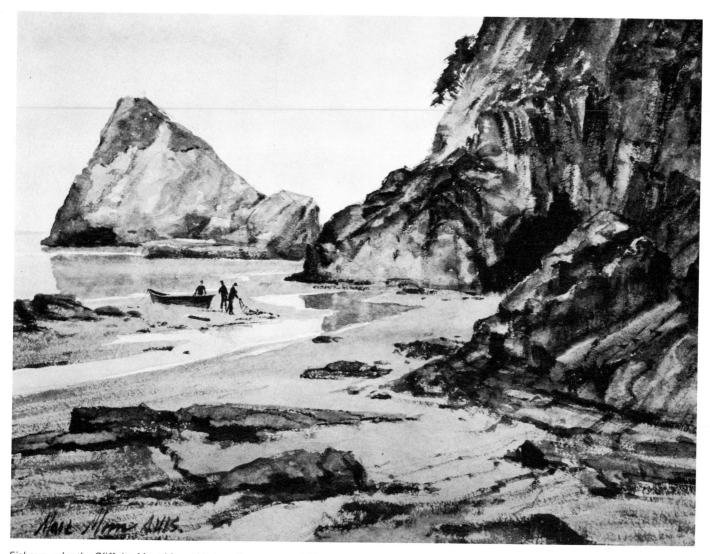

*Fishermen by the Cliffs* by Marc Moon. Watercolor on paper. Effects of deep space and distance are achieved in this panoramic composition by contrasting the large masses of the cliffs with the small boat and figures of the fishermen. The water and shorelines effectively lead the eye into the background and contribute to the all-over feeling of depth.

## Panoramic

A panoramic picture usually shows great depth and distance with large expanses of sky and land. In these pictures objects are small and the perspective is often represented as if viewed from above.

Panoramic compositions are those in which the artist can concentrate on the vastness of nature, its moods and its grandeur. Big skies can emphasize dramatic cloud formations with wide variance of color and tone. Large land masses give an opportunity to show the unique character of a location by emphasizing varieties of land contours and forms covered with many and diverse objects, subjects, textures and shapes.

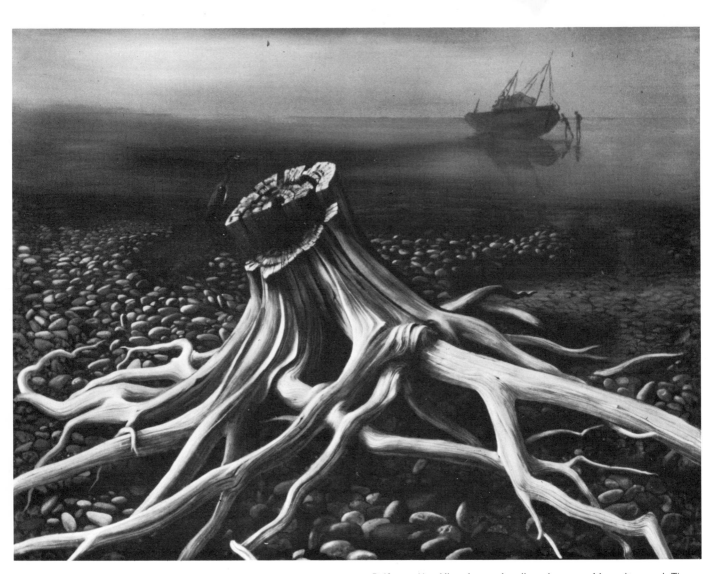

*Driftwood* by Allan Jones. Acrylic polymer on Masonite panel. The attention is focused dramatically on a single subject explicitly rendered with skill and an understanding of form. The background and the objects are played down in order to emphasize the main subject making this object-dominated composition highly successful.

## Object Dominated

The object or subject dominated drawing or painting is just the opposite from the panoramic. It concentrates mainly upon one subject which in size and emphasis totally dominates the work. While distance, space, other objects and forms may exist behind and around it, the main subject's size alone makes this type of composition one of the easiest to recognize.

This composition allows concentration upon one object or subject incorporating as much detail as you like. While the background and other areas are important, their primary function is to point up the subject. A close examination of an object in its environment or an enlarged section of the object can express things about the natural environment with a certain intimacy which is unique to this kind of work.

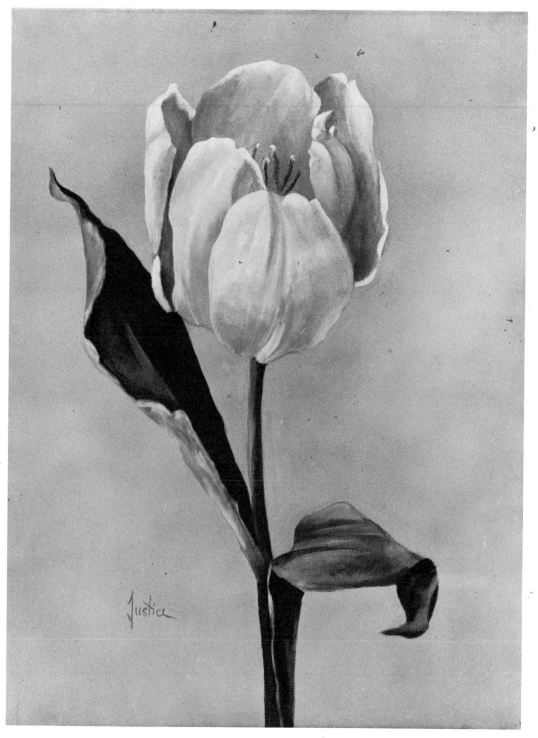

*White Tulip* by Cornelia Justice. Acrylic polymer on canvas. 24" x 30". Enlarging an object to many times its size and placing it against a simple background can give strength and monumentality to a fragile subject.

*Boat Study* by Bob Price. Tempera on illustration board. Courtesy of the Imperial Gallery, Virginia Beach. The object-dominated composition allows the artist to concentrate his interest and effort upon one subject.

Top: *Les Bords D'un Canal Aux Environs De Rotterdam* by Jean Baptiste-Camille Carot. French 1854. Courtesy of the Virginia Museum. Because it depicts some depth and distance and features activity in the middle ground with moderately large subjects properly placed, this picture contains elements of both panoramic and object-dominated composition, making it a typical example of traditional pictorial composition. In its versatility this type offers the widest range of expressive possibilities.

*Nags Head* by Ben Garrett. Acrylic polymer on Masonite panel. Depicting the background and the foreground with equal strength and emphasis places this picture in the traditional composition category.

## The Traditional

To best understand this kind of composition, think of it as combining important elements of both the panoramic and the object dominated drawing or painting. This composition gives the greatest latitude for different kinds of expression, and more works fall into this category than in any other. It usually depicts both some depth or distance as in the panoramic scene and some object or subject enlarged or close up as in the object dominated picture, but not quite as large or dominating.

## Which Composition to Use

After having examined these three types of composition, the question might arise as to how you decide which composition to use. While certainly valid, questions of this type usually answer themselves when one actually starts sketching and preparing to paint. Each of these compositions has possibilities of showing and expressing things in particular ways. What the place or scene compels you to say about it or what you decide to say about it will determine which type of work you will create.

While scouting or sketching on location, you may discover an object or subject which interests you. This might indicate that there is material for an object dominated composition. On the other hand, if an imposing or dramatic view of the general scene proves most impressive, the panoramic picture would be most suitable. If many aspects are more or less equally inspiring or interesting, and you find a decision hard to make, select the traditional pictorial composition since it has broader possibilities and can include a little of everything.

After completing several pictures, you may find that you have favored one type of composition. For variety you might then select subjects where the other types might be suitably employed. Suggested working exercises and assignments in this and other chapters will deal with this as well as related problems of this type.

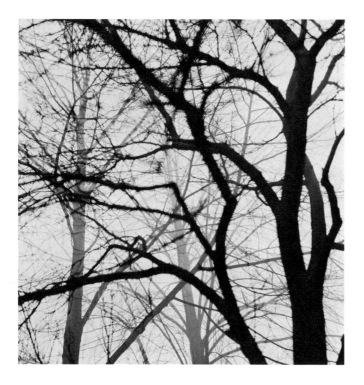

Left: Simply by looking skyward on a winter's day, one can discover interesting lines and shapes created by the naked tree branches, as did the photographer, Harry Noland.

Opposite: *The Transplant* by Allan Jones. Acrylic polymer on Masonite panel. One of the unique qualities about this painting is its straight-forward representation of a simple subject, giving it a certain magical importance. Many subjects of this type seen in reality are passed up as unsuitable because of their "unartistic" appearance.

## Getting Started with a Sketching Trip

A good way to get started in landscape painting is to take a sketching trip. The object of this trip is to gather information, subject matter, ideas and inspiration from which paintings can be created.

You may prefer to go alone or find it more productive if a fellow artist or kindred spirit goes along. Many artists enjoy going as a group. They find the discussion, exchange of ideas and fellowship encouraging and beneficial. However, the circumstances under which you go are not as important as the material with which you return. Go to get good material.

*Where to Go.* Certainly this is a matter of selection dictated by many factors, such as where you live and how far away the predominant natural environment is, as well as how easily available to transportation. Some may have a wilderness right outside their door while others may have to travel a considerable distance. Be it a rural countryside or a city park, the natural subject matter can be observed firsthand by a majority of those who profess interest in it.

Be reasonably comfortable, but travel light. Take only what you need. A cushion or a light folding chair or stool can be a great aid if you are not inclined to rough it.

Pick a good day and dress for the occasion. If the weather becomes disagreeable, seek shelter. Many good sketches can be made from a shelter point, porch or an automobile.

After reaching the location, scout or survey the general area, covering a convenient distance. This will be especially helpful if it is unfamiliar territory. Look for interesting scenes, subjects and compositions. Do a lot of conscious looking before starting to draw. Be aware of all possibilities. Be methodical; get inspiration, but don't let it keep you from gathering the material you came after.

If it helps, make a written or mental list of what and how much you plan to accomplish.

When you start sketching, work quickly and don't allow yourself to get bogged down on any one sketch. Set a time limit if you need to. Then move on to another subject. From two to twenty minutes offers a reasonable range of time for a composition sketch.

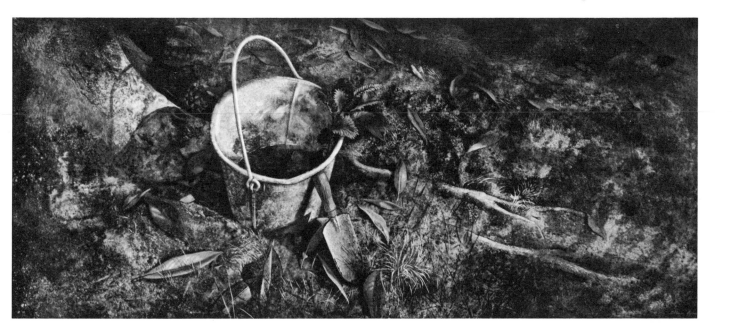

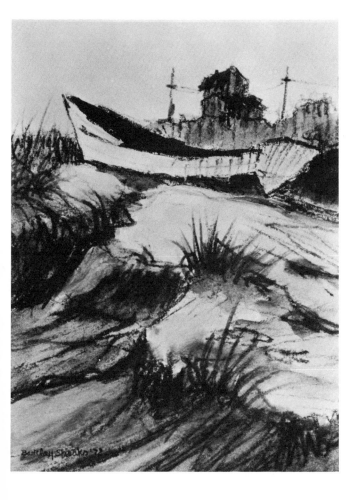

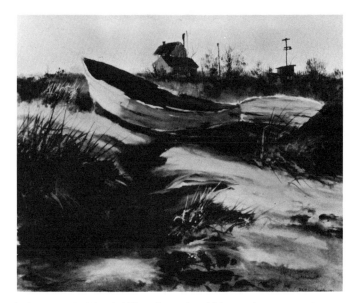

Left: *Study for Messic Winter* by author. Lithograph crayon and acrylic wash on paper. Viewing the subject from below and considering the composition as a vertical one emphasizes the height of the sloping banks and conveys a spatial feeling quite different from that of the final painting.

Above: *Messic Winter* by author. Acrylic polymer on Upson board panel. Using a horizontal composition instead of the vertical sketch gives more room to spread out the picture and emphasize the boat. Depicted either horizontally or vertically, the subject could make an interesting picture.

Have a good balance of different compositions, studies and subjects. Draw examples of all categories: panoramic, object dominated and traditional. Include some horizontals and verticals of each. Do equal amounts of both composition studies and object studies. Depending upon how long you can work on location, a total of ten to twenty-five examples including all kinds and types would be a reasonable number. If time is short, even one or two sketches would be a good start. Remember, many of the composition studies as well as the object studies may be used with some variation as picture material again and again. You are building a pictorial reference library which may be used for a lifetime.

Get the work done, but remember that you are a sensitive human being—not a machine which devours the landscape. Discipline yourself but do not become artistically exhausted from overdoing it. Therefore, the sketches should be brief and not thought of as finished products. Look forward to creating the final work; it should be the climax.

## How to Use Your Sketches

Now that you have the sketches, the next step is to make the best use of them as aids in creating a drawing or painting. You will find this creative process is more easily achieved with the sketches than without them. For one thing, it is likely that you have already made some concrete decisions concerning what you want or do not want to paint. Observing the area and doing the sketches have both consciously and unconsciously helped you in this process of deciding. You should be able to approach building the picture with some confidence because the looking and sketching have helped familiarize you with the subject matter.

If deciding upon a work is difficult even after the sketching experience, there is a logical approach you can follow. First look over the composition studies and select one which appeals to you; then sketch it lightly on your canvas, paper, panel or whatever working surface you plan to use. Now work it into a finished picture, using familiar methods. Refer to the object studies when in doubt as to the appearance of the various subjects, objects and details. Do not hesitate to adjust, rearrange or move things about in the composition if you think the appearance will be improved.

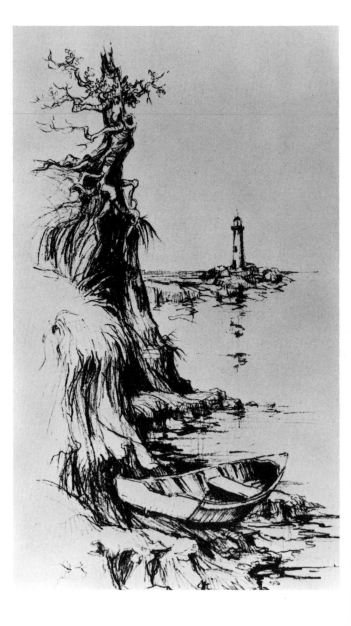

Having a variety of sketches to select from, both in subject and composition type, such as these two studies done by the author with a lithograph crayon on paper, makes finding a suitable painting subject far easier.

If none of the composition sketches inspires you, then look over your object sketches. Find an object which is particularly interesting to you and build a sketch around it. Sketch the object on the working surface, positioning it so as to make an interesting composition. You may make use of your composition study sketches for the background but most of the time and detail will be employed in rendering the object itself.

Those who lack confidence and the essential know-how to get started with any measure of hope for a successful final product will find additional information in the chapters following about procedures and methods of working step-by-step from the sketch to the finished product.

## From the Sketch to the Finished Work

When you select a medium for executing the finished work, its characteristics and qualities must be taken into consideration. A certain sequence of actions may be dictated and, in order to have successful results, the artist must follow them. For example, if you are using transparent watercolor you may have to work from light to dark, using the paper as the white spaces; you would then work around the white spaces, putting on the light washes first and working the dark washes into and over these. In some instances you might have to complete the work a section at a time. The sequence of working has been dictated by the fact that in order to retain the beauty of the transparent wash, the fluid mixtures of paint have to be applied certain ways at precisely the right time. An artist working opaquely in tempera, oil or acrylic can easily move from dark to light, light to dark, or start with a middle tone and work either way. This medium offers the freedom to work lights over dark or darks over light. If you are working in pen and dark ink, you cannot apply lights and you cannot lighten areas. Thus your working order of tonal pattern would probably be from light to dark, leaving the white of the paper exposed for the light areas. Although no washes are used, the technique for pen and ink is very much akin to that used in watercolor.

*Watcher by the Dune* by author. Acrylic polymer on Masonite panel. This painting was executed using the step method of painting.

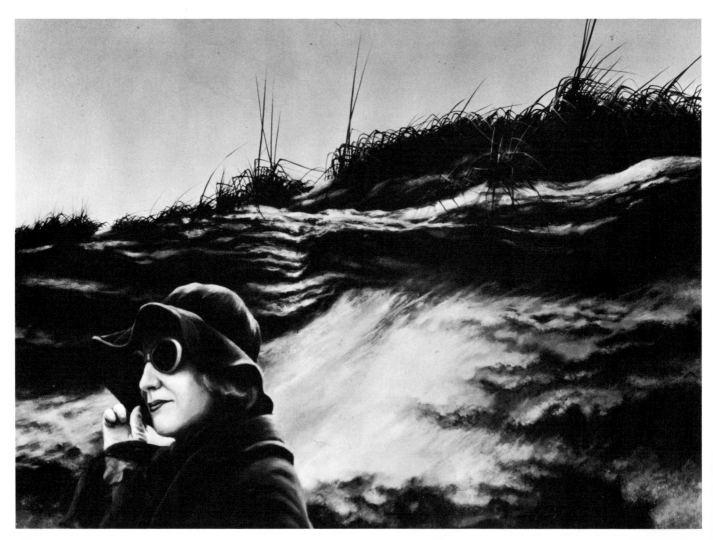

Each medium requires its own special technique of execution and its particular kind of thinking. There is no single method of working that can be successfully employed for all media. There are, however, certain factors of design and composition that deal with the structure and make drawings and paintings visually interesting which can be employed by artists working in any medium. These will be examined in the next chapter. The suggested exercises can be conveniently worked out in any medium familiar to the artist.

For the beginner who has some familiarity with the traditional painting media of oils or acrylics, step painting may prove to be a successful technique because of its simplified, logical, step-by-step approach. Step painting literally means painting a picture in planned logical layers, steps, or stages of development. While this method is easier to begin with than many, some understanding of materials, a familiarity with procedures and the mastery of some basic painting skills will be necessary for starting.

## The Step Method in Brief

This method evolves through three steps. Step one, which translates the selected composition into flat pattern shapes of basic tones and colors; step two, which takes the flat pattern and introduces both light and dark throughout the composition, color and tonal variations in the form of highlights, shadows, various textures and details; step three, in which finished details are added, all problems are resolved and the work emerges in its finished appearance as the artist dictates, whether loose and free, or highly detailed and polished.

### Before Starting Step One

1. *Question:* After completing the composition study sketches, is there anything more I can do before undertaking step one that will make getting started easier?

*Answer:* Assuming that you have selected your work surface and have your paints and other working materials ready, there is one thing you may do: be fairly sure of your composition. Artists find this helps prevent making changes and adjustments in all stages. Be sure that all of the objects and subjects are placed where you think they look best and create the most interesting arrangement. This can be done by elaborating one of the composition sketches you have already completed, adding basic tones to the various areas; or you may create a new sketch by referring to the already completed position and object studies. This is called a working drawing. Knowing beforehand if an object is to be light, halftone or dark makes it easier to mix and apply the paint in the basic tones needed for stage one. This working drawing need not be done with great detail. A simple descriptive sketch showing the location of the objects and their basic tones will suffice.

*Study for Mountain Summer* by author. Acrylic polymer on Upson board panel. Although worked very much like a wet watercolor using a wet surface and fluid washes of transparent and opaque paint, the painting evolved through three definite stages of development as in step painting.

2. *Question:* I have the sketch or working drawing. What do I do now?

*Answer:* Transfer or transpose this drawing to the working surface and you are halfway into step one. Use whatever drawing medium is appropriate for the situation. It can be simple and sketchy or precise, depending upon your preference. Place a simple linear guide on the working surface on which a basic flat pattern can be painted.

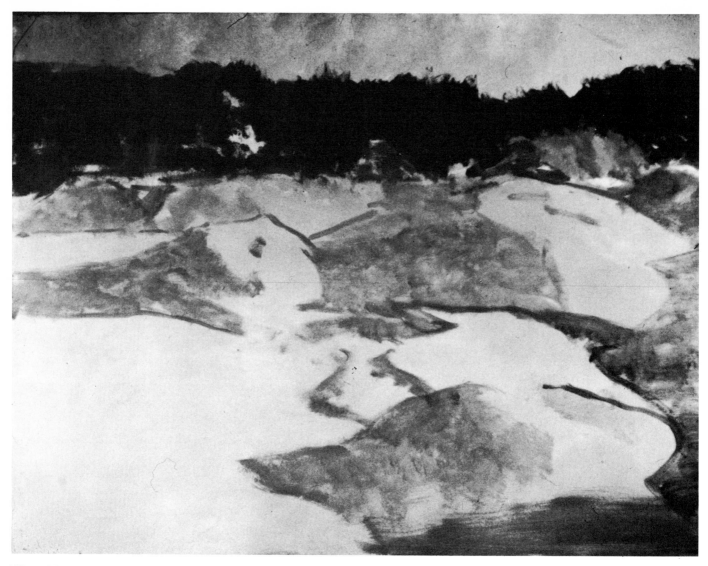

*Winter Afternoon* by Marc Moon. Watercolor on paper.          Step one of painting.

## Step One

*A Time for Basic Decision Making.*    For this
stage of development to go smoothly you should have
made several important decisions about your work. What
you do in this step will become the foundation layer.
Therefore, you should determine the general or basic
tones for the major areas of the picture, delaying con-
sideration of details and small objects until steps two and
three. Divide the entire work into its major areas and
paint them with the basic color tones. Many artists refer
to this procedure as the roughing-in stage, meaning the
colors and tones are applied quickly and loosely without
concern for neat, smooth outlines and contours.

Questions Which Might Occur About Step One

1. *Question:* What are the basic areas and how do you decide how many to use for each picture?

*Answer:* Basic areas are those areas, objects or subjects which occupy an important space in the picture. At this stage the basic shapes or spaces would be large, certainly no less than medium sized. No small areas or objects would be included. These smaller areas will be painted into or over the large areas created by step one.

2. *Question:* Give an example of how a typical landscape can be simplified into basic shapes?

*Answer:* A typical landscape might be reduced to basic shapes like areas of land, sky, and trees or forests; these shapes would also indicate which might occupy sizable portions of the work, such as rocks, bushes, houses, lakes, ponds, and so on.

3. *Question:* Do I leave a blank space for small objects on the working surface while I am roughing in or painting step one?

*Answer:* No. Paint over the space where the objects will be located; leaving a space for them or painting around them takes too much time. It is easier to draw or paint them on the work after step one, the first layer, is completed.

4. *Question:* How do I decide what the basic colors and tones are to be?

*Answer:* By using logic and by observing. Areas and objects get their basic tones and colors either by their natural residual color or tone, by light and shadow, or in some cases, by both. Look at a sky and determine whether it is light, halftone, or dark; then determine what color it is. Is it blue or grey or whatever? If it is light in tone and grey in color, mix an appropriate thin mixture of light grey paint and apply it to the working surface. The same logic can be applied to the other areas of the picture. If an area or object is a mixture of different colors and tones, determine the dominant one in each category and use it for that entire area.

There can be reasons for selecting colors and tones other than realistic or descriptive. Additional information on this and other factors of design will be covered in the next chapter.

5. *Question:* Why can't I just start painting and finish my picture an area at a time? Why start with simple shapes and areas painted basic colors and tones?

*Answer:* Certainly, at times, one can finish areas piecemeal, including details, and have them turn out successfully. More frequently, however, concentrating too soon on finished details in isolated areas results in a disorganized, visually confusing composition that lacks unity. Starting with basic shapes allows the artist to concentrate more easily on thinking of the picture as a unit, putting in and adjusting all elements so that they work together.

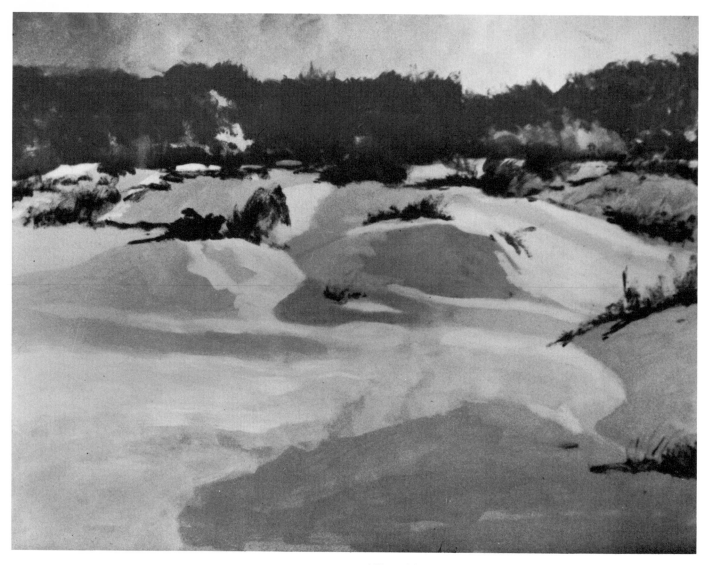

*Winter Afternoon* by Marc Moon. Step two of painting.

## Step Two

*Building and Adjusting.* Your work at this stage is ready for evaluating, for adjusting colors and tones and for positioning objects.

Study your picture and make compositional and other changes. Changing basic shapes is much easier than changing finished areas, objects or subjects that are filled with completed detail. At this stage you can begin to model, to shadow, and to add variations of color, tone and texture. Now you can add small objects, put in some details and complete other portions. By evaluating, adjusting and balancing; by working over the entire picture, bringing it to approximately the same degree of finish, you are ready for the final stage, with a well balanced, related, visually unified work nearly completed.

*Question:* How do I know when I have finished this step?

*Answer:* The time when a step is completed is not always easy to recognize. Frequently the transition from one step to another is practically unnoticeable and before you realize it the picture is finished. Progress from step to step involves mental awareness as much as it does any exact point of work on the painting. When all objects are in the right place and are the right color and tone; when you have added and adjusted; when you have modeled and refined and have indicated some detail; when you have a fairly clear indication of what the finished work will look like without major changes—then you are ready to move into step three.

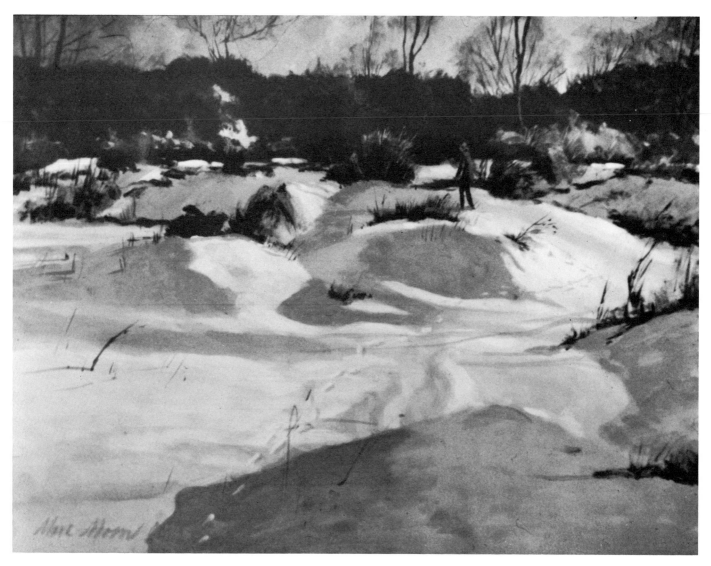

*Winter Afternoon* by Marc Moon. Step three of painting.

## Step Three

*Enhancing the Final Appearance.* Just as the fledgling gets its flight feathers, the work gets its final details as the image crystallizes. But in thinking of final details, do not mistakenly associate details and finish with being meticulously precise. Completed and finished work can be either loose and free in paint application and appearance, finely detailed and restrained, or somewhere in between. Final appearance depends upon the character of the picture and the determination of the artist. A picture's being finished means that it has become resolved; the problems have been solved; the result is visually interesting and has the unity of a completed work.

At this step, because major developments and alterations are complete, one can concentrate upon varying the tones and colors. Edges and contours can be softened or sharpened; subjects and objects can receive final attention and detail. You can add small lines, textures and patterns. All this should be done with a careful eye so as not to overdo it. This stage should most often consist more of looking than of painting.

*Forest Glade* by Edna Love, student, Chesapeake Bay Art Association. Acrylic polymer on Masonite. A finished painting may be highly detailed with much modeling and shadowing or be simply descriptive with flat patterned shapes. Style, technique and appearance are dictated by the personal choice of the artist, the pictorial design problem he wishes to solve or the idea he has chosen to express.

Questions Which Might Occur About Step Three:

1. *Question:* How do you know when a picture is finished?

*Answer:* This is one of the hardest of all questions to answer because it deals as much with a feeling about the whole work and how you wanted it to look as it does with technical knowledge. Unfortunately what we do come to painfully realize as we continue to work on a picture at this stage is that we have lost something. Unfortunately we have not gained enough to offset the loss; it is, in effect, ruined not finished. As long as you are doing something *for* it, continue to work; when you start doing something *to* it, it is time to stop.

2. *Question:* If you realize that you have overworked a picture and the results are greatly detrimental, should you continue working on it?

*Answer:* It depends upon the individual picture, the capabilities of the artist and the nature of the problem. Sometimes all that is needed is a pause, some perceptive looking, and some real thinking and feeling. Then a deft touch, an alteration or two, and all is well. Sometimes, the more we work, the worse it gets. Any drawing or painting worth the time and effort of doing is worth some effort in trying to save. However, if it means having to repaint most of the work completely, then it would be better to concentrate that effort on beginning a new picture.

Much has been left unsaid about the step method of landscape painting; this would best be learned by doing.

Personal choice may dictate some variation of the method set forth here. It certainly should not be thought of as the only valid or valuable approach. It can serve as a working guide through which a growing artist can experience some success while developing the uniquely personal approach which works for him.

Suggested Exercise for the Step Method

Review your sketches and select a picture that is not too complicated. Choose one with a familiar subject and without too much detail. A simple composition will make it easier to concentrate upon building the work through logical steps of development without getting bogged down with detail, subject matter and technical difficulties. Select a manageable size; undertaking a work too large or too small can prevent achieving the original objective.

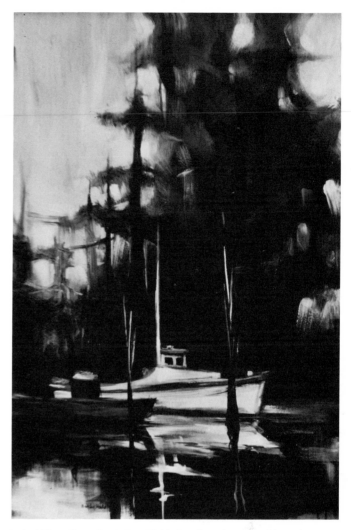

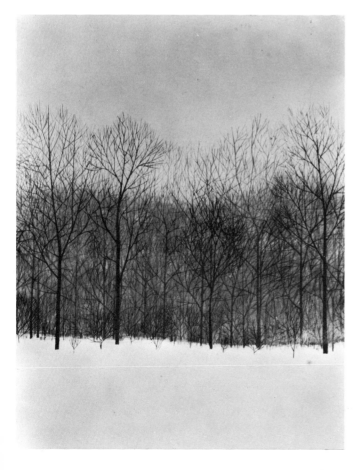

Left: *Winter Trees* by Arthur Biehl. Acrylic polymer on Masonite panel. Some subjects lend themselves to delicate delineation, precisely rendered.

Above: *Boats at Mooring* by author. Acrylic polymer on Masonite panel. Certain subjects, depending upon the artist's conception, can be appropriately represented by using loose and free applications of paint creating soft blended edges and forms.

# Design as a Factor

## Design Awareness Can Help Your Work

What is it that makes a completed work enduringly interesting, continually rewarding? One might offer many quick answers to this question and find them all true in part. An interesting subject can attract and hold the attention but interest in a subject can fade rapidly. The way a drawing or painting is executed (i.e., its style, technique and materials) certainly creates interest. Technical brilliance can by itself become empty and hollow; exotic materials once understood are no longer enigmatic; colors and mood can exhaust the eye and mind. In a general statement, one might say that no one of these elements alone makes a work visually interesting; but rather, it is what the artist does with them that makes the difference between an exciting picture and a dull one. The way the artist combines these elements becomes much more important than the elements themselves. A painter must compose. He offers the observer an interesting optical experience or an enchanting visual journey. This is what it is all about.

The artist has many choices of ways and elements he can employ to accomplish this. These basic elements are line, shape, form, color, tone, texture and pattern. The way in which they are combined in the work is called composition or picture structure.

Many people question the necessity for studying design in painting. One immediately has visions of complex diagrams with diverse shapes and swirling movements, arrows and opaque descriptions. These objections may have merit, but the study of design can be approached from a practical point of view and easily employed to help create more interesting paintings. This chapter will illustrate design as applied specifically to landscape painting. However, these principles could be applied in any mode or style of painting. By using practical exercises which explore the various design elements in creating original pictures from nature, the student can achieve a better understanding of the importance of design and how to apply it.

Dividing the picture almost in the middle as in the center illustration creates equal amounts of space above and below this main dividing line. Because of this, the space divisions are not as visually interesting as those in the illustrations on the left and right which are unequally divided.

## Dividing the Space

It is not at all hard to see how a landscape can be reduced to simple divisions of space. A scene consisting of land, water and sky could actually be depicted realistically by three slightly irregular, different colored bands or stripes. Once this is understood, it becomes much easier to see drawings and paintings divided into underlying spaces not merely into subjects, objects and things. When you can recognize these spatial divisions, you are beginning to see and think abstractly. You have reached an understanding of what design really is.

If pictures are space divisions, interesting divisions result in interesting finished works. One way to achieve interest is to vary the size of the basic spaces. In a picture made up of mainly horizontal stripes or divisions, uneven or unequal divisions are more interesting to the eye than even or equal ones. A landscape picture which shows some difference in the expanse of the sky, land and water areas will be more interesting than one in which all are the same. When you realize this, you have discovered the secret of variance which will have many valuable compositional uses.

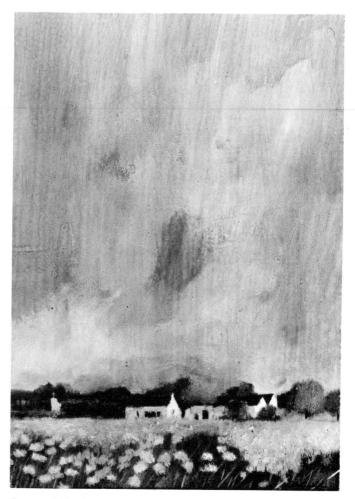

*Farm and Meadow* by Vance Mitchell. Acrylic polymer on paper. The large sky area contrasted against the small areas of the meadow, houses and trees results in a strikingly dramatic picture.

Suggested Exercises in Spatial Division

For an exercise designed to make you aware of consciously planning and controlling the size of the division shapes, select a simple composition that consists mainly of three horizontal divisions and try several combinations of variance. Sketch simple pictures and find a combination which seems most interesting to you, then create a finished work from this sketch.

Much or wide difference in the size of the divisions creates a dramatic visual appearance. Less difference or variation creates subtle interest. Equal spacing can result in a boring composition.

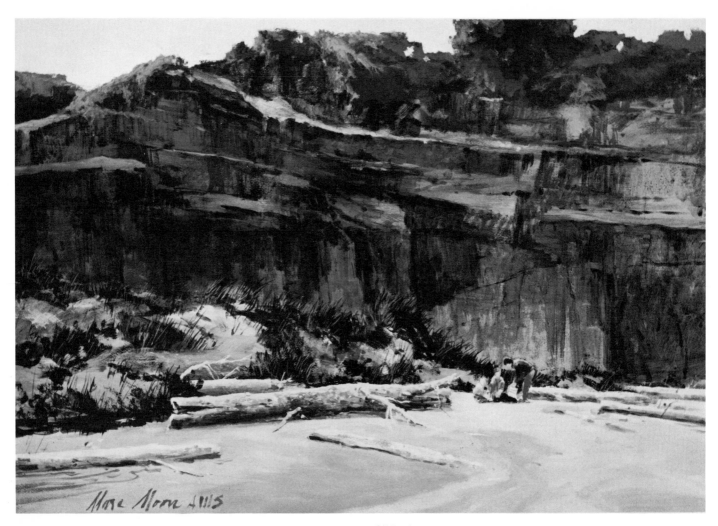

*Cliffs along the Shore* by Marc Moon. Watercolor on paper. The long horizontal divisions of the shore and rock ledges are interestingly offset by the vertical lines running through the rock cliffs. The whole picture is a clever arrangement made up almost entirely of rectangular shapes in endless variety of sizes and positions.

## Line—How It Can Help You

Line is one of the most versatile of all the design factors.

Almost everyone has an innate sense of what line is. For our purposes, think of line as being a relatively long, thin shape.

A brief examination of the possibilities of line will prove sufficient to convince one of its vital role in picture building. Line has the amazing capacity to create movement, shape, form, mood and emotion — to make an area interesting, to direct and lead the eye. There are many sorts of lines: thick, thin, straight, curved, some are definite and visible, others implied and invisible. All of them can affect the way we feel when looking at a work of art. Perhaps the most pronounced and useful characteristic of line is its ability to lead the eye.

*Summer Marsh* by author. Acrylic polymer on stretched canvas. A picture based on simple divisions of varying size can be made visually interesting by adding light and dark tones and by contrasting textured areas against areas without tones.

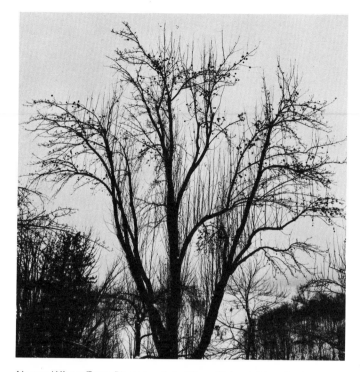

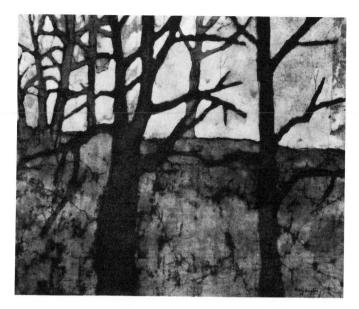

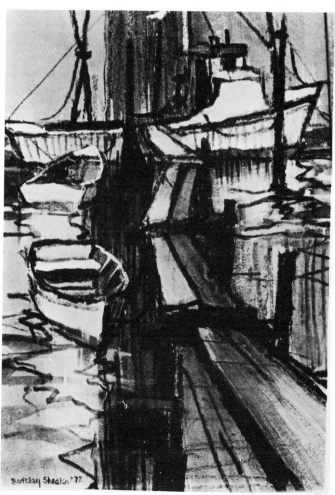

Above: *Winter Trees* Photograph by Harry Noland. Lines in nature can be found literally everywhere. These trees, when seen against the light background, form a strong linear pattern.

Above right: *Trees* by Betty Anglin. Batik painting on cotton fabric. This exciting pattern uses trees to break up the space in a linear fashion.

Right: *Deep Creek Study* by author. Acrylic polymer wash and lithograph crayon. The lines of the boards in the pier lead the eyes to the oyster boat. To avoid directing the vision too rapidly, the pier was depicted in a zigzag, broken manner instead of in a smooth, direct line.

***Directing and Leading the Eye.*** Even when we are not aware of it, our eyes are following lines. It may be a shoreline, a line of trees, the flight pattern or path of a bird, the curving sweep of a sand dune or cloud bank. Nature abounds with lines which lead us along, around, over, and into. Our vision flows rapidly along sweeping, straight, unbroken lines—slows down and enjoys graceful curves, whirls through loops and swirls and proceeds with caution over the jagged and abrupt. When we become conscious of this movement, our appreciation of nature can become broader because we are aware of it in a new dimension.

***Outlines and Contours.*** Whenever a line encircles, surrounds, or encloses an area, that area becomes a shape. The outside edge of a shape is usually referred to as a contour. We cannot look at a shape for any length of time without tracing around its contour in both directions. Contour lines or border lines, where shapes come to-gether, are definite or visible. When painting the shapes and forms of nature, what is done with the contours can make the painting interesting as well as authentic.

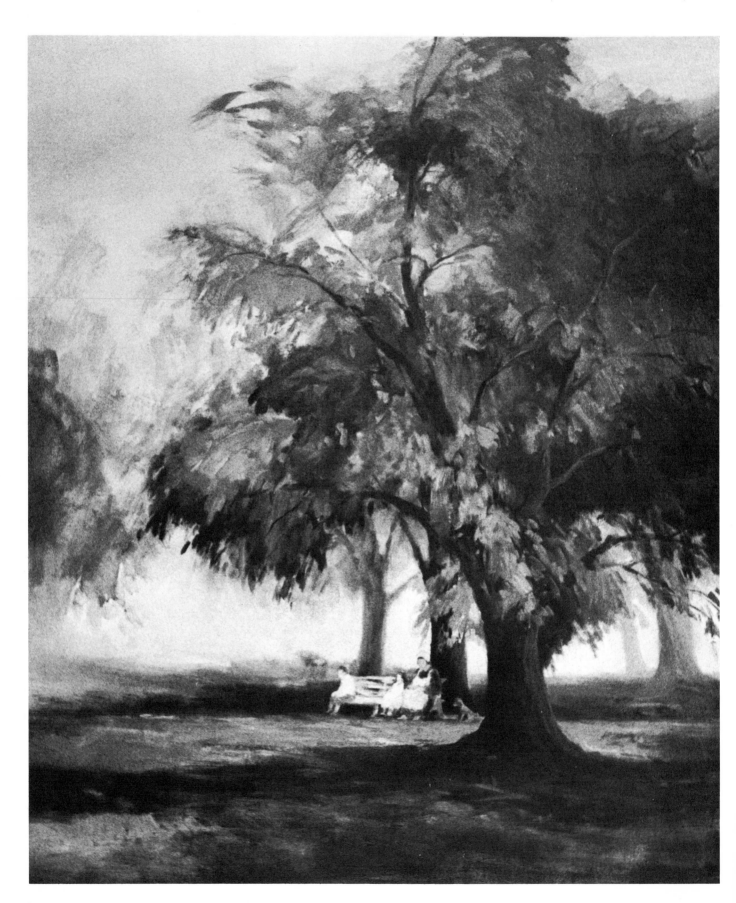

Opposite: *Trees* by Charles Sibley. Oil on canvas. Courtesy of the Imperial Gallery, Virginia Beach. Artist Sibley interprets nature with sensitivity and authenticity, displaying a keen awareness of the beauty of shape as well as a feeling for light and space.

Above: *Contour Drawing* by Mary Evans, student, Chesapeake Bay Art Association. Ink on paper. This contour drawing, describing only the shapes of the objects, accurately conveys their individual characteristics. Accomplished drawings like this can only be produced after the artist has carefully observed the subject.

Above right: Untitled drawings by Gayle Brown, student, Chesapeake Bay Art Association. Ink on paper. These drawings depict the subject in two ways: as outlined shapes with tone and texture. Each way has its own beauty and expressive possibilities. The outline drawings have the beauty of simple descriptive clarity while those with tone and texture possess the added dimension of tone and the visual interest of texture.

## Exercises Using Contour Lines

Often an artist will experience difficulty in his attempt to represent accurately some subject or object from nature. The trouble is not an inability in drawing or painting but a failure to understand the subject because he has failed to really observe it. Accurate drawing comes as much from seeing with understanding as it does from technical skill. Most people look at nature, the landscape and the objects in it in a general way. The following simple exercises in looking and drawing can help to improve your ability both to observe and to draw by looking at and drawing contours.

Select an object like a tree in full foliage or an interesting piece of driftwood, seashell, or other natural object which has an interesting shape and contours with variety. Imagine that your eyes are a pencil and slowly trace the exact contour. Go into each concavity and carefully around each irregularity; then go back the other way. This kind of exercise may be practiced anywhere natural objects can be observed. Brief sessions worked in while relaxing between other activities are valuable as well as enjoyable. For variety in this exercise, trace the contours of one subject from several viewing points.

Next, combine observing with drawing. Take a pencil, ballpoint, or felt-tipped pen and paper. Now carefully draw with a single outline the subject as you observe it. After executing several of these, try drawing a whole landscape in which you represent everything in single outlines. These drawing and looking experiences will make you aware not only of line but also of shape.

## Invisible Lines that Thrust

Shapes not only have outlines which direct our eyes around their contours but they also have lines of movement or force which thrust our path of vision into spaces where there are no lines. Elongated shapes assume a directional thrust, acting like large lines; our eyes move through them and continue moving for a space of time after passing through the shape. Thus, a cedar tree is not merely a realistic object in a picture; it is a shape that takes the viewer on a journey around its shaggy outline, and, because of its pointed, elongated shape, it thrusts upward like a large arrow carrying the path of vision with it. Artists learned very early in history that shapes have this quality and made clever use of it both to lead the eye through the picture in an endless variety of ways and to point up particular subjects or objects.

These directional thrusts, when used in certain combinations, can strongly influence the mood of the picture. Understanding this can be useful in many ways. A good way to begin this understanding is to examine some basic directional thrusts and see what effects they have on pictures.

When one kind of movement or directional thrust in a picture predominates others, the whole picture assumes a particular character. This is a good time to go into the theory of dominance which, like the theory of variance, has wide application and use in pictorial composition and design.

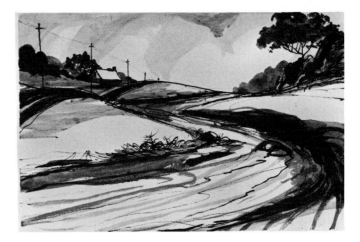

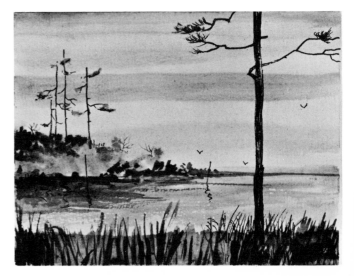

Artist Ken Bowen did these three paintings to illustrate the visual effect brought about in a picture when certain kinds of directional thrusts or movements dominate the composition. The top picture has strong diagonal movements or thrusts using straight lines and sharp angles. This creates a feeling of strong movement and dynamic action. The picture in the center uses diagonal movements but they are predominantly curved instead of straight. This gives the picture a feeling of graceful movement. The bottom illustration shows the effect of calmness and placidity that is created when the dominant movements are horizontal and vertical.

**Diagonal Thrusts.** If the dominant thrusts in a composition are diagonal, the results are frequently dramatic. The name usually associated with this visual effect is dynamic. Just how dynamic the composition is depends upon other factors such as the angle of thrust, the degree of harmony or opposition, and the number of curved and straight lines used. Straight lines with strong angles and plenty of slant create more action than those with less angle and slant. Curved lines soften the thrust and take away some power; if they dominate, the effect can become undulating and graceful.

When the dominant lines of thrust are mostly horizontal and vertical, the visual effect can range from statically calm with straight lines to gracefully placid with curved lines.

Suggested Exercises in Linear Movement

1. Study the illustrations of linear movement in this chapter and then do sketches of your own subjects to illustrate the various dominant movements.
2. Paint two pictures of the same scene. In one attempt to show calm and in the other dynamic action.

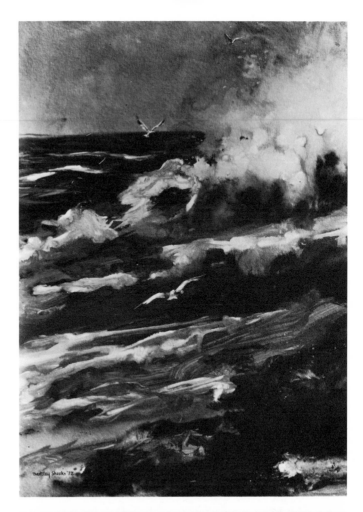

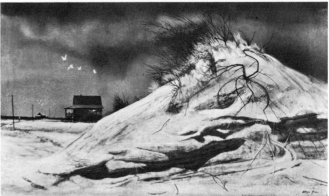

Top: *Surf at Hatteras* by author. Acrylic polymer on Upson board. The diagonal thrusts help convey the dynamic quality associated with the pounding surf.

*Dune Study* by Allan Jones. Acrylic polymer on Masonite panel. Diagonal thrusting lines when softened into curves still create activity and movement, but the visual effect is graceful rather than abrupt or dynamic as conveyed by jagged, abrupt straight lines. This poetic study uses curved lines to advantage.

Above: *House At Dusk* by Edward Hopper, American, 1935. Oil on canvas. Courtesy of the Virginia Museum. The predominance of straight horizontal and vertical lines gives an effect of static calmness, quite suitable to the overall mood of the picture.

Right: *Meadow* by Larry Knight. Acrylic polymer wash on illustration board. The predominant use of curved horizontal lines gives it an overall effect that is gracefully calm. The soft, blended painting technique and graduated use of tone and color contribute much to this quality and feeling.

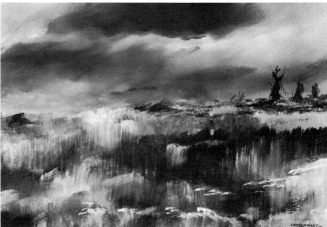

## Shape

A shape is an enclosed area. Shape is dependent upon line and grows directly out of it. The study of contours and outline has made you aware of this design factor but there are other facets equally valuable in creating successful landscape paintings.

Shape means area and space as well as outline. A shape is flat and two-dimensional; it has width and length but no depth. It can have an infinite variety of contours and sizes. Like line, shape can lead the eye and create form. Our concentration, however, is going to be directed to shape's importance in flat areas. Recognizing this can help make you aware that all areas of a picture contribute to the whole.

### Two Kinds of Shapes: Positive and Negative

There are basically two kinds of shapes, positive and negative. Almost all pictures contain both shapes. Think of positive shapes as being the shapes of things or objects which populate a picture—trees, house, rocks, people, and so on. Negative shapes are those areas which occur around and between the positive shapes. These areas, skies, fields, water, and so on, are often thought of as background.

When painting, artists too often concentrate on positive objects and forget the importance of negative background areas. If backgrounds are not right in size and proportion, the positive shapes will not be seen to advantage. To get an idea of how interdependent the two are, try the following exercise in drawing.

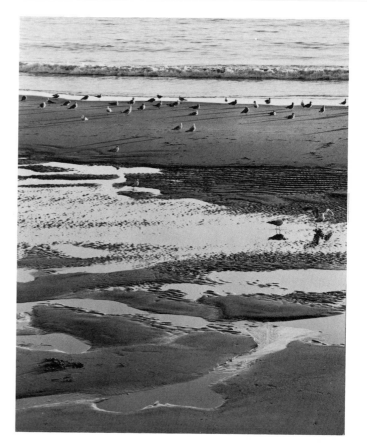

Top: The captured tide pools left by the receding tide create an endless variety of shapes and patterns easily recognizable in this photograph by Harry Noland.

Right: *Untitled drawing* by Mary Evans, student, Chesapeake Bay Art Association. This line drawing done in ink on paper illustrates the concept of negative and positive shapes. The positive shape is the vase of flowers and the negative shapes are those areas between the flowers as well as the large background area.

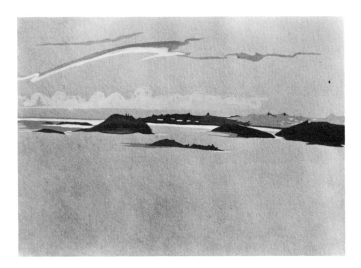

*Islands in the Sea* by Elmer Midgette, student, Virginia Wesleyan College. Acrylic polymer on canvas. This painting, which represents the subject as flat shapes, emphasizes the beauty of pure shape sensitively positioned with a strong awareness of space.

A Suggested Drawing Exercise in Negative Shape

Find a tree without leaves or an interesting grouping of several trees with foliage; even an interesting piece of driftwood will do. Carefully study and draw the spatial areas around and between the subjects. You might experience some initial difficulty in looking at and treating the negative space as if it were a positive object. The eyes will have a tendency to look at the subject instead of the background shapes. If you do a good job of drawing these background areas, you will find that the space you have drawn around will become the recognizable subject which you were trying to avoid drawing. You will also notice that the subject suffers when the drawing becomes confused in the background shapes. It should take only a few exercises like this to convince you of the importance of each and every kind of area in a picture—its shape, size and proportion—and the interdependence of them all.

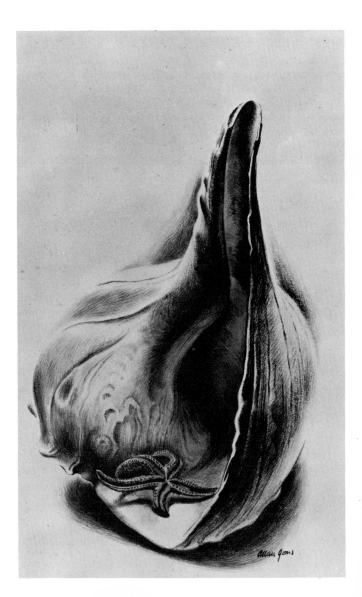

*Shell Study* by Allan Jones. Ink and brush on illustration board, using the dry-brush technique. To represent form in nature graphically requires the ability to create the illusion of three dimensions using line and tone. Artist Jones brings to his interpretations of nature not only talent and technical skill but the complete understanding of his subject evidenced in this study of a shell. If an artist does not understand the structure and form of a subject, he cannot draw and paint it convincingly.

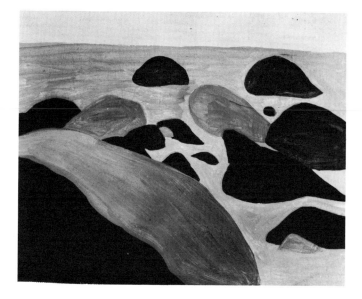

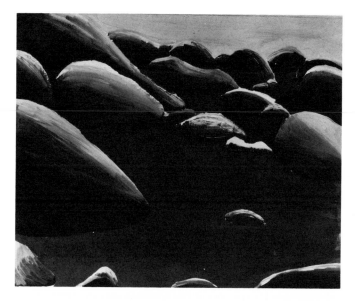

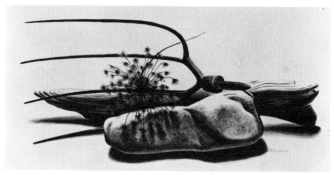

Top, left and right: Untitled shape and form studies by Terry Klopfenstein, student, Virginia Wesleyan College. Acrylic polymer on paper. These simplified examples take the same subject from nature and stones, and represent them as flat shapes and then as strong three-dimensional forms.

Right: Untitled drawing by Allan Jones. Ink and brush on illustration board. Strong contrast of light and dark tones and the depiction of the subject as if seen under a single strong direct light give an effect of strong form.

## Form

Just as shape grew from line, form grows out of and depends upon shape. Think of form as shape with three dimensions. For our purposes, form in painting and drawing is the illusion of three dimension, of solidity and roundness. Objects that have form show depth. Form can do many of the things which other design factors do—only in its own special way. It leads the eye and creates pictorial interest by adding depth and contrast. The most obvious ways of creating this special kind of depth are by employing descriptive line or by using tone to model and shadow. The artist's knowledge and skill in creating and giving form to a subject frees him from depending upon the light conditions of the natural setting, which can be difficult. Strong form can help create visual interest because of its rich tonal contrast; strong forms stand out in a picture and attract attention. Artists who depict stark realism frequently use this principle to advantage. Because the technique of creating form by tone, light, and shadow is so useful, our study of form will concentrate on that aspect.

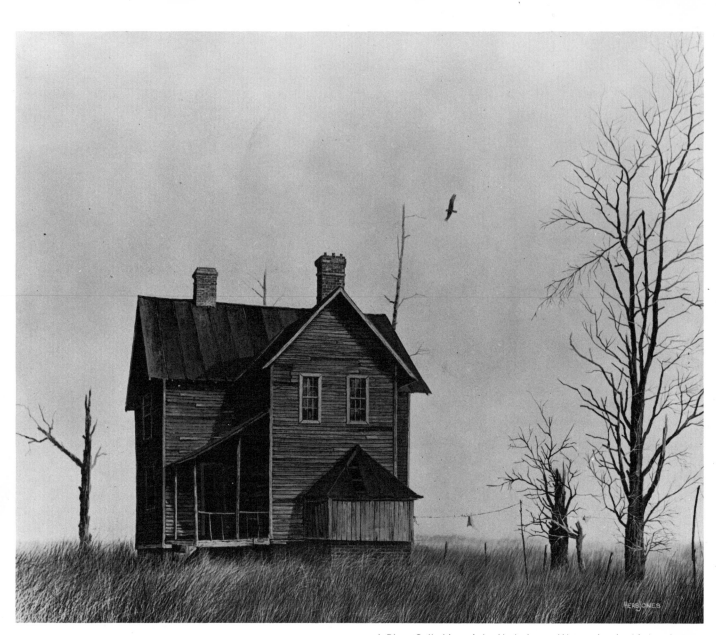

*A Place Called Lonely* by Herb Jones. Watercolor. In this handsome painting the form in the weathered building is stressed by rendering it as if a strong light were falling upon it from a single source.

## Form Through Tone, Light, and Shadow

Tone, which we will use to create form, is a design element in its own right. Tone is the lightness or darkness of a color. To guide our thinking and to illustrate the subject, we will deal mainly with three basic tones: light, dark, and the one midway between these two, called halftone or middletone.

Light is an essential ingredient in the creation of form. The direction from which the light is coming as it strikes the object is also important and is usually referred to as light source.

Now that you understand the terms, the easiest and most effective way to create strong form in painting and drawing is to model and shadow the subject as if a strong light were striking it from a single source. The parts of the subject closest to the light source will be light. The next closest areas will be halftone and those areas furthermost from the light source will be dark. The contour and the surface quality of a form influence its appearance. The edges of the lights and shadows on rounded and curving forms are soft and graduated while those on angular

The tree in the illustration on the left has been modeled and shadowed as if illuminated from a single light source. This gives it the appearance of having strong, solid form. The tree on the right is represented as if illuminated by lights coming from many different light sources. This random scattering of lights and darks has a tendency to destroy form rather than create it.

Untitled drawing by Jim Hill, student, Virginia Wesleyan College. This strong drawing illustrates clearly how solid, three-dimensional effects can be created in a picture by modeling and shadowing the forms with great light and dark contrast. The quality is increased when reflected lights and other light sources are eliminated and one direct light source is employed.

forms are sharp and clean cut. Rough surfaces reflect the light and hold shadow in quite a different way. Some observations will acquaint you with these differences.

Because of the many conflicting light sources that exist under natural conditions, pure strong form is difficult to find. This is why artists seeking form frequently prefer to find their subjects in bright sunlight where form can be seen and studied to advantage. Under most natural conditions, the many light sources and reflected lights tend to flatten out objects and portray them more nearly as two-dimensional shapes. Fortunate is the artist who does not have to depend solely upon existing environmental conditions and can use form as his creativity dictates.

Untitled drawing by Allan Jones. Ink and brush on illustration board. This unusual drawing of weathered metal machinery parts demonstrates graphically how the shadow and light edges differ on rounded forms and angular forms. The lights and shadows on rounded forms are soft and graduated while those on angular forms are sharp and clean-cut.

Suggested Exercises in Discovering Form

The purpose of these drills is to aid you in learning to see form in nature and to be aware of its potential as a creative tool.

Take a field trip to discover form. Don't plan to draw—just look, observe, study and touch.

1. Look for as many different examples of form as you can, both large and small. Curving, rounded forms may be found in hills and valleys, sand dunes, weathered rocks and stones, in the cylindrical and conical forms of trees, seashells and similar objects. Angular forms may be found in mountains, broken stones, jagged rocks, plateaus, walls and shoreline banks and in man-made forms, such as buildings, roof tops, boats, and other constructions. Try to imagine how these forms would look if dramatically lighted, modeled and shadowed with a single light source, achieving extreme contrast in lights and darks.

2. Pick up small forms like pieces of wood, shells, rocks, clods, seed pods, and so on. With your eyes closed—touch, feel and rub them, tracing their surfaces and contours with your fingers, trying to visualize the various forms in your mind.

3. By looking and touching, experience the difference in surface textures. Notice how a given surface feels and how it looks in light and shadow.

4. In the studio, study the form of small objects under a spotlight. Make some tone drawings of them, lighted to advantage.

5. On location, make a drawing of a subject which has possibilities of strong form. Draw it clearly with line, then finish it at home by giving it strong form with extreme lights and darks.

6. Plan and complete a finished and detailed work in which your main goal is to depict strong form. Select the subject matter which will best serve your purpose.

Above: *Pacific Rocks* by Gerald F. Brommer. Watercolor and rice paper collage. Strength and a feeling of monumentality are achieved by stressing the form in the rocks.

Right: *Dawn in Virginia* by Kenneth Harris. Watercolor on paper. This striking water scene by a gifted artist illustrates clearly two kinds of strong form: the rounded cloud forms of nature and the sharp angular forms of the man-made structures.

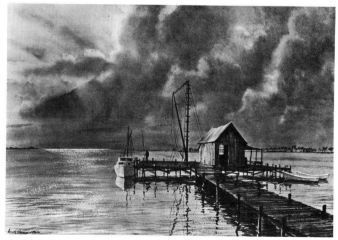

## Color and Tone

Color and tone are major design elements. Both can change and influence the appearance of a picture. They can communicate with intimacy and quickly strike the viewer's emotional chords. They contain the flexibility needed for a wide range of expressive possibilities and combinations. Tone is a quality of color. However, for those who execute finished works in black and white or in monochrome, we will study tone as a related but separate element.

### Tone, The Light and Dark Factor

Everything that is visible has tone, every color has tone, every shape and form has tone. As mentioned previously, tone is the lightness and darkness of color; tone may range from the lightest lights to midnight darks. As in the unit on form, this study will use the three basic tones of light, halftone, and dark. Additional tones will unavoidably and naturally grow from these basic three while work is in progress. Because tone is such an important part of the artist's vocabulary of expression, learning to use it effectively can add immeasurably to the success of your finished work.

Artist Ken Bowen did the three interesting studies above of the same scene to illustrate the tone domination theory. The picture on the left is an example of a light-dominated composition. The center illustration is halftone dominated, and the picture on the right is dominated by dark tones. Notice how different each picture appears even though the subject and composition are identical. The mood of each is also different, illustrating the importance of tone in the pictorial depiction of mood and emotion.

Opposite: *Summer Afternoon* by author. Acrylic polymer on Upson board panel. High contrast achieved by using tones of deep darks and bright lights can give a picture a dramatic visual strength. The effect of bright sunlight is achieved by having the lights and darks occur next to each other.

Below: *Cove* by author. Acrylic polymer wash and lithograph crayon on Upson board. The visual interest of a picture can be increased by using the tone domination theory to advantage. This sketch study is an example of halftone domination in a picture, with lights and darks used in minor amounts as accents. The shapes and forms are sharp-edged and clean-cut adding to the contrast.

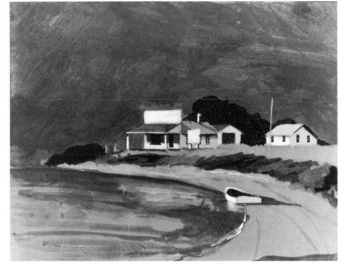

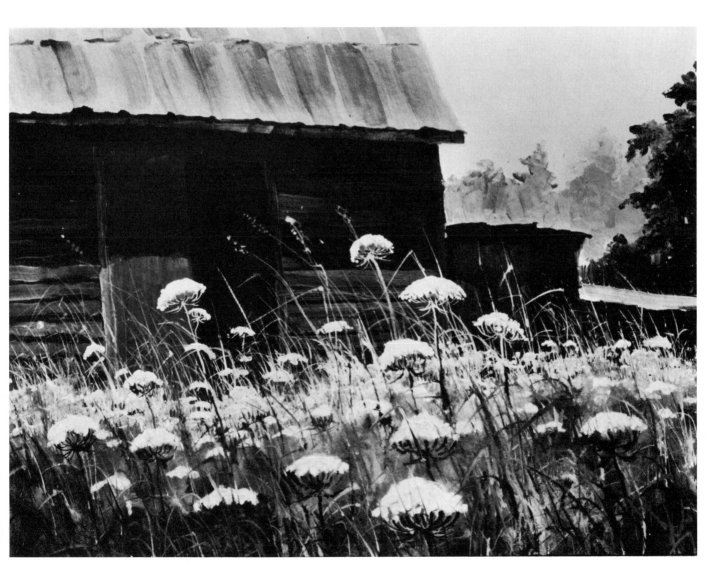

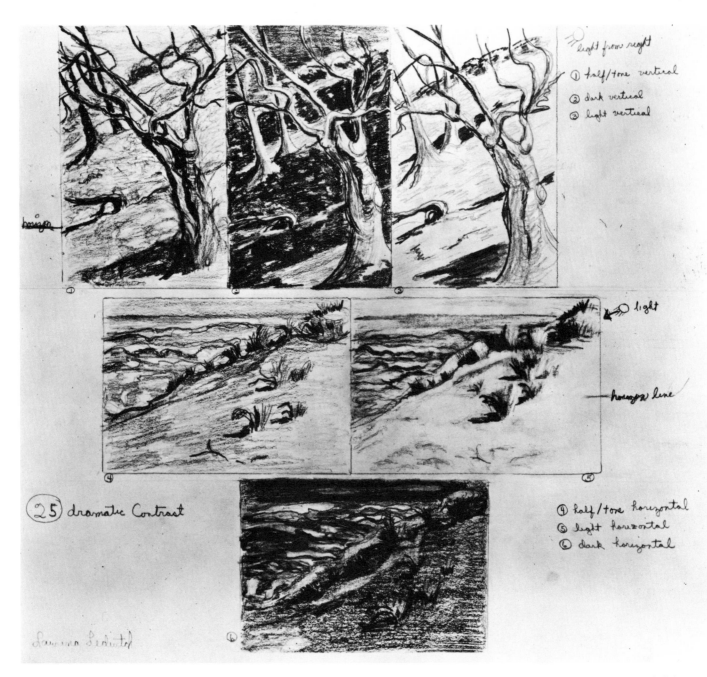

light from right

① half/tone vertical

② dark vertical

③ light vertical

horizon

←— light

horizon line

㉕ dramatic Contrast

④ half/tone horizontal

⑤ light horizontal

⑥ dark horizontal

Laurina Ledwitch

Page from a sketch book by Laurina Ledwitch, student, Virginia Wesleyan College. These pencil studies show two different subjects each depicted three times with a different tone dominating each illustration.

## Tone Domination Theory

Now that you are familiar with the theory of the dominant factor introduced in discussing linear movement and thrust; i.e., where one element can dominate a picture, the idea of tonal domination will be easy.

Usually drawings or paintings that are interesting and successful in their use of tone are dominated by one of the three basic tones. This means that much more of one is used in the picture than any other. The remaining two are used as minor factors or accents. Understandably then, a dark dominated picture would have dark in the majority with light and halftone in the minority. The same would apply if only two tones were used in a composition. The picture would prove more appealing to the eye if one of them were to dominate.

While this theory can become very complex with many variations and combinations, the simplified version works effectively and will make a good solid base from which to grow in your ability to compose.

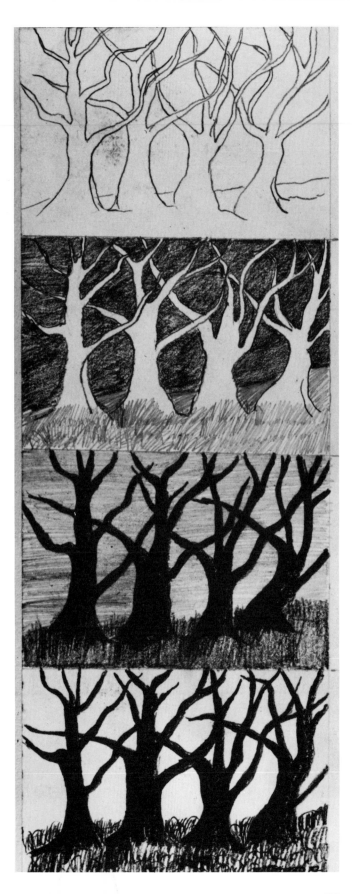

*Tree Studies* by Frank Trozzo, student, Virginia Wesleyan College. Pencil on paper. These drawings are experiments in tonal domination using the same subject. Notice the great difference in mood and appearance of each even though the subject is drawn and spaced essentially the same.

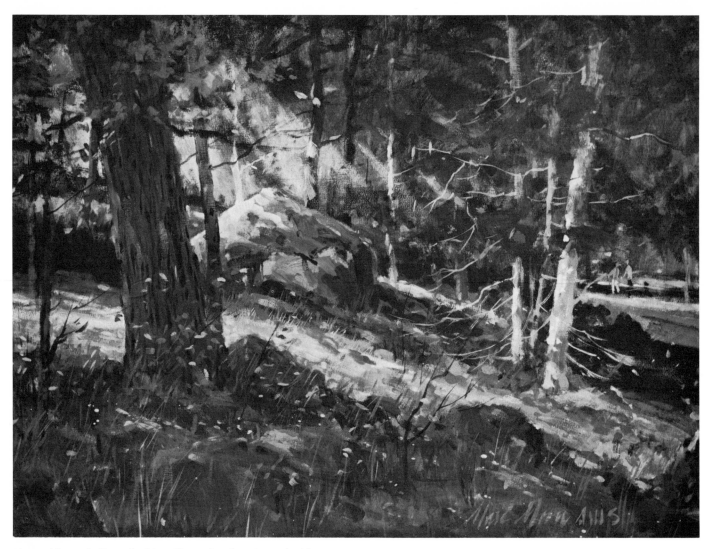

Above: *Mountain Forest* by Marc Moon. Acrylic polymer. In this picture dark dominant tones help capture the feeling and mood of the deep forest illuminated by the filtered sunlight. Moon, a gifted artist, knows how to use the principle of tone domination to heighten the mood of the picture.

Opposite: *A River Landscape* by Salomon Van Ruysdael. Flemish, 1600-1670. Courtesy of the Virginia Museum. This light-dominated picture captures that particular luminous quality of the sky frequently noticeable in the morning and early evening.

Suggested Exercises Using Tonal Domination

1. From your composition sketches, select one which would make an interesting finished work. Then rough sketch the composition three times, using a different basic tone to dominate each study. An easy way to do this first experiment is to use the major dominant tone in the larger areas of the picture and the minor accents in the smaller ones.

You may be surprised to find how completely different each study looks, as though each were an entirely different picture. Thus you have a good example of how tone can influence the appearance of a composition.

2. If you still think it suitable material for a finished work, select the most interesting of the three studies and use it as a tonal guide for executing a completed picture.

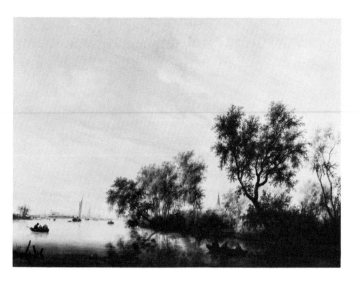

## Some Practical Help in Color Mixing

Much of the confusion about mixing color in paint has been caused by the fact that there are several valid theories dealing with color, its qualities and use. All are very similar, all differ in some ways, and all of them work when applied in context. Some deal with color as light, which it is; some deal with color as pigment and paint, which it is. However, pigment and paint cannot be mixed or used quite like light; this is where the trouble arises. We shall deal mainly with color as pertaining to the artist's paints.

Refresh Your Memory about Some Aspects of Color

1. There are a number of different colors. The quality which enables us to recognize this difference is called hue.
2. Color has a range from light to dark. This lightness and darkness is called tone or value.
3. Color has brightness, not to be confused with lightness. This brightness means the amount of color in a given tone. Think of this as color power. It is known as intensity. A color that is not bright is referred to as subdued.
4. The three primary or basic colors are red, yellow and blue. Ideally, all colors can be made by mixing these three. In application, most can, but many when mixed will be subdued and lack intensity. This is why manufacturers offer a wide range of colors of different hues and intensity.
5. The secondary colors are green, orange and violet. They result from mixing the primary colors, one with another.
6. The more colors you mix to achieve a particular hue, the more subdued it becomes.
7. Colors can be thought of as falling more or less into two groups or families, warm and cool. The warm colors, like sun and fire, are red, yellow and orange. The cool colors, like ice and cool water, are green, blue and blue-green. Some colors are mixtures from both families (for example, violet, and yellow-green, as well as white, grey and black) can fall into either category, depending upon what other colors are used with them.
8. Relatively speaking, warm colors tend to come forward in a picture while cool colors tend to recede.
9. Colors can influence moods and arouse emotions.

## A Word About Using What You Have Learned

Becoming a good landscape painter is similar to developing any other skill. Some of it comes naturally, but, for the most part, it requires hard work. Part of this work is making a conscious effort to practice what you have learned.

The goal of the exercises suggested in this book is to encourage the student to experience, by doing, the beneficial effects that intelligent, constructive planning can have upon his drawings and paintings. Adherence to the following three words in their respective order will prove beneficial: FEEL, THINK, EVALUATE.

Color—The Big Dimension

Color offers the artist a wide range of expressive possibilities. New discoveries about old qualities of color and what can be done with it are always evolving. As long as an artist is visually aware, he can always grow in his feelings for color and his understanding of it.

We shall briefly review some of colors' basic properties which support the examples used here; it is not intended that the subject be covered completely. It is assumed that the student has some prior knowledge of color. For those who need a more inclusive or detailed coverage, there is much published information available.

Practical Color Aids for the Landscape Painter

A good place to start an investigation of color is with a list of usable information and facts pertaining to color, with special concern for certain colors predominantly used in traditional landscape painting.

1. When trying to achieve paint mixtures of colors in light tones, add small amounts of pure color to white until the desired tone is reached.

2. To reduce or subdue the rawness or intensity of a certain color, mix in a little of that color's complement. For example, if the color you want to subdue is a warm one, experiment with adding very small amounts of cool colors until the result is satisfactory. Use the reverse procedure if the color to be subdued is a cool one.

3. Make use of blues and greens. In most traditional landscape painting, more blue and green are used than any other colors. The two most frequent abuses of these two colors are using them too pure, raw or intense, and not using enough variance of hue when they occupy a major portion of the picture's space.

Electric blue sky and water and pool table green trees and vegetation glowing with intensity can be beautiful in a picture where the other colors match their intensity and power. All too often they do not. These colors can be subdued by mixing into them minute amounts of warm colors. Browns and orange, for example, work well for blue while reds and browns may be used for green.

To avoid the monotony of using the same greens and blues, experiment with achieving variance by mixing either warm or cool colors with them. Tonal variance can also help create interest. An exercise planned for this purpose will acquaint you with this principle.

4. Select and use colors for their beauty and contribution to the drawing or painting as well as for their ability to describe nature. Not every slice of nature comes interestingly composed, harmoniously toned, colored and framed. This means that the artist has to shuffle, change, adjust, add to and subtract from, tint, tone and abstract. In other words, *COMPOSE*. When working from nature, take a long studious look at the scene. If the color that will help you achieve your goal for the picture is there, use it. If it is not there, add it. If there is too much, eliminate it.

Above: Color is a vital element in this painting, but even when reproduced in black and white this inventive hard-edged picture by Cameron Bone-Kemper presents a strong and successful visual pattern because of its interesting use of light and dark.

Opposite: *Winter 1972* by Robert Marsh. Craypas wash. Tone is a very important element of color. The arrangement of the lights and darks in a composition constitutes a major element in its success or failure. This light-dominated picture demonstrates this with startling clarity. The positioning of the dark spots in the form of vegetation, buildings and trees played against each other results in a uniquely balanced structure. Our eyes are led from one dark spot to another. This unusual picture of a common and much used subject matter is better than most paintings of snow scenes because of its compositional strength and individualistic approach.

## A Basic List of Colors for the Landscape Painter

A good start in investigating color for the landscape painter is to consider the selection of a good working palette of colors. This is not easy since every locale has its special tints and every artist has his own eye through which he views nature and makes color selections. A good basic list is one which will accommodate most situations but can be added to when needed. It is with this in mind that the following list and descriptive comments are offered.

1. *Red:* Cadmium red medium or Quinacridone. A good rich red, one that is not too orange or pink, is hard to find.

2. *Yellow:* Cadmium yellow medium. This color is not greenish or orange. It is a deep, pure buttery yellow necessary for mixing varieties of tints and hues.

3. *Blue:* Thalo or ultramarine. You need strong dark blues that will hold up well when tints are made by mixing white with them. Dark blues will be needed for mixing with other colors to produce rich dark tones. Mixed with burnt umber, they result in a lively black. Both can be used for glazing; the thalo is especially good for this purpose.

4. *Brown:* Burnt umber. There are several usable browns; burnt umber is a good selection because it has a fine, transparent, dark body, good for glazing and it does not grey out when mixed with white.

5. *Green:* Thalo or Hooker's green are excellent dark, strong colors with enough power to create infinite varieties of greens when combined with other colors. Many beginners shy away from using them because of their brilliant, acidy color. Additions of browns, reds, yellows and oranges will alleviate and modify this condition.

These five colors, plus black and white, will give you a limited but adequate working assortment which can be added to as the need arises. When a particular color cannot be mixed by combining those you have, add it to your list. You could expand its possibilities greatly by adding orange, violet and raw sienna.

## Color Domination

By now, if you have experienced the suggested exercises, the idea of dominant factors in a pictorial composition is familiar to you. Color domination is similar to tonal domination and, like it and other dominant factor theories, it is but one of the many aspects of design which can be simplified into an idea to be applied practically in picture building. To put color domination into practice, you need some familiarity with the main difference between warm and cool colors. A brief review of this aspect of color might prove helpful before attempting the suggested working exercises.

Under the traditional concepts pertaining to the pictorial use of color, pictures appear to be more successful when a composition is dominated by a majority of either warm or cool colors. Equal amounts of each will cancel out or negate each other and result in a frustrating or uninteresting appearance. If a picture is dominated by cool colors, the warm colors will be used as accents. A composition dominated by warm colors will feature the cool colors as accents. While this concept works within the context of its intentions, it cannot be used as the sole criterion for successful color application. There are instances, for example, where more or less equal amounts of contrasting warm and cool colors of great intensity can be used effectively to create varieties of optical vibrations and illusions. Nevertheless, color domination, as applied to traditional, realistic landscape painting, is a valid concept which can be a great aid to the painter in composing interesting and harmonious pictures.

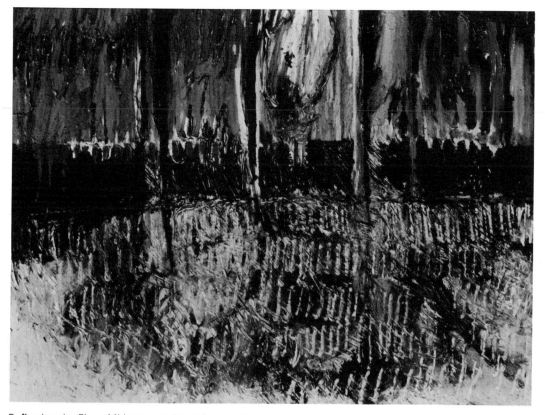

*Reflections* by Elmer Midgette, student, Virginia Wesleyan College. Oil on canvas. One way real texture can be created is by using paint in heavy textural applications. This impressionistic study utilizes another method effectively, that of scratching into the heavy layers of wet paint with a palette knife.

## A Working Experiment in Color Domination

Because of the complex possibilities of color, one could hesitate attempting to use color at all. While our approach to the theory of color domination is simple and practical, certainly there is ample room to broaden it into a sophisticated, involved system of great depth. A little common sense coupled with the same amount of confidence is all that is necessary for starting. Your approach to color will change and broaden as you become aware of its possibilities.

A good exercise to develop a sense of how color dominance works is to create two different color sketches of the same scene, one warm-dominated—the other cool. A typical subject could be a field with a farmhouse. If you are literal minded and require a realistic reason for the selection of colors, use a different season of the year for each sketch. In the warm picture, use browns, oranges and yellows for the fields and foliage. Allow these colors to dominate by making them strong and having them occupy the major spaces of the composition. The cool accents can be achieved by using greys, blues and whites in the sky and farmhouse.

To make the same scene cool-dominated, shift the season to summer or spring, where the green fields, foliage and blue sky dominate the composition. The warm accents will come from minor amounts of browns and reds in the farmhouse, barn, tree trunks and other objects. The winter season, with ice and snow in the landscape, easily lends itself to a cool-dominated picture.

The farm scene is only a suggested example; select any suitable subject or scene for this exercise. Be sure to select one readily adaptable to either warm or cool domination. When planning these sketches, combine your knowledge of tonal domination and light—dark variance with this new understanding.

## Using Color to Create Mood and Emotion

While personal interpretation and subjective reaction play important roles, a planned, intelligent selection and use of color in a work can influence the emotional reaction to it. There are many gifted and successful artists who select and use color in an interesting and exciting way without considering the emotional aspect of it. Some knowledge of its use, however, can help in arriving at a broader more total understanding of color.

Much can be learned from the references we make to color in our everyday conversations. For example, we often hear "I am feeling blue today," which means that the speaker is lonely or in low spirits. We frequently hear, "I was so angry I saw red." The meaning is self-explanatory and obvious. So, too, are many other such references and sayings. To further understand this concept, study the following list of some widely accepted but very general color and mood associations:

1. Pale and muted colors are associated with quiet, mild and thoughtful moods.

2. Bright strong colors are associated frequently with strong, forceful and active emotions.

3. Dark tones and colors bring to mind fear, violence and death.

4. Bright warm tones are often used to depict gaiety, joy and love.

5. Hot reds, violets and pinks are associated with strong feeling and passion.

6. Blues and greens, if not too intense, are restful colors, often used to represent calm, quiet and solitude.

7. Somber greys and browns are often used to depict bleakness, lifelessness and isolation.

### Experiment in Mood With Color and Composition

Color can bring about an emotional reaction or mood in the observer. This knowledge can be an important tool for the artist. The way a picture is composed, the kinds of compositional movements used, as illustrated in Chapter 3, can also influence the reaction of the observer and help set a mood for the entire picture. Many times, when attempting to create a mood in a drawing or painting, artists thoughtlessly select compositional movements and colors which work against each other. For example, in trying to bring about a feeling of calm stability by using muted blues and greens, one might unthinkingly select a composition dominated by severe diagonal movements and thrusts which create a feeling of dynamic action. These are not at all appropriate for the work intended to portray a calm restfulness. A composition in which horizontal lines or movements are dominant would be much more suitable.

Before embarking on your experiments of creating mood in a picture involving color and composition, you might refresh your knowledge of the basic compositional movements so that you can coordinate the two elements more effectively.

This working experiment will be divided into two parts: the first part consists of planning and thinking; the second part deals with the actual creation of a picture depicting a mood.

1. Review the section in Chapter 3 that illustrates and explains the basic compositional movements and types of linear thrust and the parts of this chapter that concern mood, emotion and color. After doing this, make a list of some general moods or broad emotional states; such as calmness, solemnness, joy, violent passion, etc. Then select or plan compositions which would be appropriate for each mood.

2. From your list of moods and corresponding compositions, select one to build a landscape painting around. Use a scene or locale with movements and subjects which can be easily adapted to the colors and compositional movements needed to depict the mood. Then select your medium and begin to create the picture. It might prove helpful if a pencil sketch were made beforehand to act as a guide.

Put into practice all of the design factors with which you are familiar. Take time from the actual painting to have occasional evaluation sessions in which you check and adjust the composition so that all elements work together in the finished picture.

### One Question Most Frequently Asked About Color

*Question:* You hear so much about color harmony and about colors not being compatible, is there any formula for selecting "good color combinations"?

*Answer:* Many colorists would agree that a successful or "good" color combination is one that combines colors in a way that achieves the total effect sought by the artist, whether it be an effect of contrast or one of harmony. Nevertheless, there are numerous formulas for successfully combining colors. Without going into great detail, the following are only a few of many:

1. Close color harmony. This consists of using colors that are closely related. This means they occur next to or close to each other on the traditional color wheel. For example, red, red-orange and red-violet are closely related, as are violet and blue, blue-green and blue-violet. Using this combination with the addition of white and black will assure safe and interesting results.

2. Any one or two colors combined with black and white will always work.

3. Combinations arrived at by using the color domination theory as presented in this chapter are usually successful.

4. Use color for a purpose. The intelligent and sensitive use of a few colors is far better than the thoughtless, indiscriminate use of many.

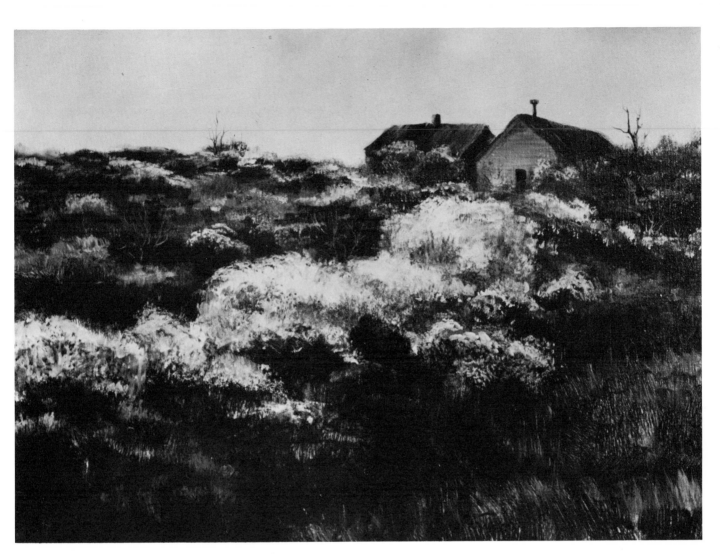

*Autumn Marsh* by author. Acrylic polymer on stretched canvas. Owned by Mr. and Mrs. J. D. Gregory. Visual or simulated texture may be achieved in paintings without thick applications of paint by using various dry-brush and stippling techniques. To prevent too much conflicting visual activity by simulating all of the natural textures in this setting, the grass was kept low key in tone so that the blossoming myrtle could dominate. The sky is plain to act as a visual rest area from the texture.

## Texture

Texture has to do with the surface finish of shapes, forms, areas and objects; their roughness, smoothness or shininess. Even though texture has a visual appearance, we experience it through our sense of touch. When we look at a shiny piece of glass, a rough woven fabric, or a furry kitten, our knowledge of how these things feel to the touch influences our reactions to them.

The painter deals with two kinds of texture which we will call real and visual. Real texture results when the artist uses his media and materials in such a way as to produce raised and incised textures which not only can be seen but felt when touched or rubbed. Textural additives such as sand and sawdust as well as collage also create this kind of texture.

Visual texture is arrived at by simulating its appearance. For example, the sheen of ice, water and glass can be rendered on either a rough or smooth working surface without using textural applications of paint. The rough appearance of gravel and sand can be captured without actually using raised or pebbled paint applications. In

Above: *Oceanside No. I* by Arthur Biehl. Acrylic polymer. This super realistic study by a gifted artist shows clearly how simulated textures can be rendered with surprising reality.

Right: *Winter Field* by Arthur Biehl. Acrylic polymer. Artist Biehl uses texture selectively to enhance this sensitively balanced composition. The use of restraint in the textured field and the flat empty sky give visual impact to the fence and gate, creating an example of skillful understatement.

fact, the finished surface of a work depicting these textures can actually be shiny and smooth to the touch. Real textures and visual ones are frequently used in a single picture. Texture can enrich a picture, add authenticity and realism and create interest in a way that nothing else can.

## Using Texture to Help the Picture

To aid you in understanding the possibilities of texture let us examine several situations that often confront the landscape painter. Selective and intelligent use of texture determines the finished painting's overall success.

## Using Texture Selectively

The natural environment abounds in textural examples. Everywhere texture is literally vibrating, stimulating the visual and tactile senses. Each individual texture is interesting in its own way and, when employed in a picture, creates interest and attracts the eye. By repeating the same texture in several places, this eye-catching quality can be advantageously used to lead the eye through a picture. In attempting to be very realistic, the artist often tries to simulate with equal emphasis all of the natural textures in a particular scene or location. This may work successfully if there is a good balance of rest areas to contrast with textured areas. However, if too many different kinds of texture occur next to each other or if the whole scene is a composite of many varieties, then the result could be over-active, over-stimulating and lead to visual fatigue, frustration or confusion. Instead of being attracted to the picture, the eye wants to avoid it.

In this instance there is too much texture available. A workable rule is to eliminate portions of it; depict some areas in a smooth, simple manner; play up one or two areas and tone down the rest. Artists sometimes over-emphasize texture. In attempting to be authentic and realistic, they examine each subject, form and area individually, isolated from its surroundings. Look at each texture in relation to other textures, tones and areas. When this is done, many textures, although individually striking, blend into their surroundings and become shadowed forms or flat areas of tone and color. Squinting while studying a scene is a good way to simplify textures visually.

Perhaps a composition needs interest—the texture of the scene is very calm or bland. Here is an instance where adding texture can enhance the picture rather than detract from it. One learns only by experimenting, trying to become more aware of textural possibilities in pictures as well as to see texture more in its natural state. The following exercises in observing, drawing and painting are suggested to help increase your awareness.

Suggested Textural Exercises

1. To become more aware of texture in the natural environment take a field trip to view texture. Take special

Interesting textures may be found everywhere in the natural environment. Learning to look for them can give much pleasure and broaden our appreciation of nature. Texture can add interest to realistic art and offer exciting design possibilities for the abstract painter. This close-up photograph of a worm-eaten, weathered piece of wood is an example of the many that exist.

notice of how some texture is visible when the subject is viewed at a distance; for example, the textures of sand, gravel and tree bark. Some subjects such as trees, grass and ripples on the water are apparent as shapes, forms and objects when close to the observer. When seen from the distance the forest becomes a shaggy textured shape, the grass a fabric of tiny woven marks and the ripples an area of linear vibration.

2. Experience as many of the textures as possible by touch and sight. Try to organize them into as many classifications as you can: smooth, rough, granular, shiny, shaggy, slick, prickly and so forth.

3. Textural rubbings are an excellent way of combining touch with sight. To do a rubbing, take a piece of light-weight paper like sketch or typing paper, place it firmly against a textural surface and rub it with a black crayon or a soft pencil. The raised portions of the textured surface will catch and hold the crayon or pencil, creating a visible, graphic design on the paper.

Subjects which have the pronounced and definite textural surfaces ideal for this experiment are stones and rocks, ferns and leaves of various kinds, wood with a raised grain, an arrangement of grasses spread on a flat, smooth surface, tree bark and other such surfaces. This exercise is a lesson in itself but some of the rubbings may also be attractive enough to mat and frame. They may also be used as resource material for abstract designs.

4. Try a painting in which you apply most of the paint with a palette knife in a heavy and raised manner, striving to recreate and represent natural textures. Scratching, incising and scraping into the freshly painted areas can also provide interesting results.

5. Try a collage in which you glue various man-made and natural textured materials to portions of the picture to represent natural texture. These may be left as is or painted over with colors.

6. Try creating a relief painting where the underbody of the picture is built up in textured relief by applying layers of acrylic modeling paste with a knife and allowing it to dry before painting.

## Perspective

Perspective means a method of looking at things. Most often it is associated with ways of achieving depth in a picture. The method most associated with the term deals with the theory of using lines in a logical manner to create depth and space. Another term often used is *aerial* or *atmospheric* perspective. This deals with the change in the appearance of objects as they recede into the distance, becoming muted in color and softened in contour. These are only two of the numerous visual devices and methods.

The term "accurate perspective" is often misunderstood and misapplied in respect to landscape painting. In many instances, one kind of perspective is used as the sole criterion for judging the value of a creative work, while the tone, character and objectives of the work are disregarded. We shall consider "correct" or "accurate perspective" as being the use of any method that may be appropriate to achieve depth in a particular picture. By appropriate, we mean the method or methods most suitable to the picture's character and objectives.

Too frequently the term perspective is thought to deal exclusively with logical but confusing mathematical formulas derived from diagrams of buildings or roads and fashioned from receding lines, eye levels and vanishing points. While the information these formulas offer is valuable, the beginning painter often finds difficulty in relating it to everyday, practical problems. In this chapter we will consider various isolated and related methods of achieving pictorial depth, offering simplified and practical examples of how they can be used. We will deal with the basic problems concerning depth that the beginner most often encounters when attempting traditional landscape painting. Those curious about more scientific and sophisticated approaches will find detailed information in other publications devoted entirely to perspective.

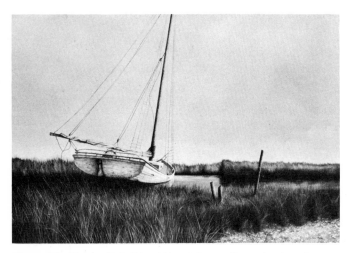

Above: *Big Moe* by Bob Price. Watercolor on illustration board. Courtesy of the Imperial Gallery, Virginia Beach. The various textures represented in this picture give it realistic authenticity.

Right: Textural nature rubbing by Dorothy Arey, student, Virginia Wesleyan College. Crayon on paper. This striking design was created by placing a sheet of thin paper over a knot in a flat wooden plank and rubbing the surface of the paper with a black crayon. The position of the paper was shifted several times during the rubbing process to give interest to the design. An abstract painting was later composed from this pattern. (See color illustrations).

Left: Experiencing and seeing depth in nature depends upon the position of the observer in relation to the subject or the scene. Photographer Harry Noland captures depth by viewing the subject through the trees in the foreground and by using the lines in the field to lead the eye into the distance.

Above: *The Road to Nowhere* by Herb Jones. Watercolor. This capably painted study shows a good understanding of space and depth and uses effectively several methods of creating this illusion pictorially. Those easiest to identify are: positioning the buildings so that two sides of them are visible, showing their basic form; using the road to lead the eye back into the picture; and, the repetition of objects, diminishing in size as they fade into the distance as illustrated by the use of the buildings and trees.

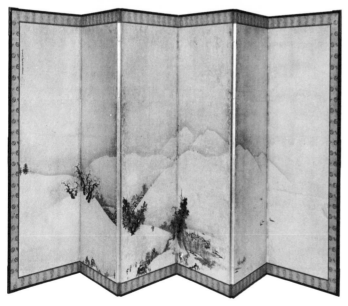

*Winter Landscape* by Unkoku Toeki. Second part of a pair of screens representing autumn and winter landscapes. Japanese 17th century. Courtesy of the Virginia Museum. This painted screen achieves a remarkable amount of depth mainly by the use of overlapping shapes and form. The planes created by the folding of the screen itself give another dimension of depth to the total concept.

## Why Create Depth?

Certain types of depth can create a strong feeling of authenticity and a kind of realism that accurately reminds the viewer of a particular place. Depth can direct and lead the viewer's eye; it can make objects and subjects stand out and be clearly identified; and it can give interest and unity to the composition. Despite these powers of realistic perspective, some artists consider it detrimental to their pictures. They believe the illusion of depth destroys the flat painting surface and draws the viewer away from the beauty of the flat pattern.

*Mountain Farm* by author. Acrylic polymer on Masonite. A feeling of depth and distance without using a middle-ground is brought about by moving the observer's eye directly from the foreground with its large clearly defined shapes and forms to the background with its small, diffused and hazy shapes and forms. The contrast between the large and the small, and the hard edges and the soft edges, can be used effectively in portraying a certain type of depth.

*Shenandoah Farm* by Allan Jones. Acrylic polymer on Masonite. Depth is achieved in an effective but unusual manner in this picture of a Virginia valley. The weathered siding boards project our eyes across the middle-ground to the hillside in the background. The foreground, middle-ground and background all have important roles in this depiction of depth.

Nevertheless, the traditional landscape painter ought to be aware of the need for pictorial depth and should know how to create it. The following suggestions should be helpful:

1. Overlapping shapes and forms. Depth without deep space can be created in this way. Illustration by Allan Jones.

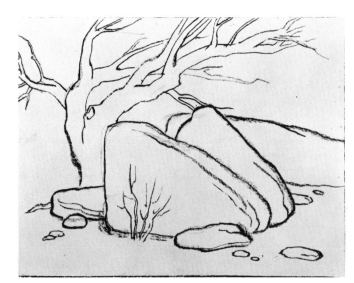

2. Progressive repetition of shapes diminishing or increasing in size. Any repetition of shapes and forms moving up, back or across the picture plane and getting progressively smaller or larger can create either an illusion of depth or of great space. Rocks and boulders strewn along a beach or trees marching across a hill create such effects. In this way, the artist makes use of the visual fact that objects appear to become smaller as they move away from the observer. Illustration by Allan Jones.

4. Soft and sharp edges and contours. Forms and shapes with sharp, crisp contours and edges stand out. They appear to come forward in contrast to those that are soft and blended, which appear to recede or to stand in the distance. Illustration by Allan Jones.

3. Parallel lines moving into the distance appear to get closer and closer together. This can be observed in roads, streams, fence lines and hedgerows. Lines such as this, when depicted as if viewed from above, can emphasize deep space. Illustration by Allan Jones.

5. Tonal contrast. Objects, shapes and forms which contrast most sharply in tone to their surroundings will appear to stand out or come forward as, for example, a light spot against a dark area or a dark spot against a light area. Illustration by Allan Jones.

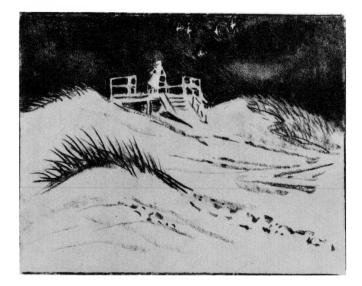

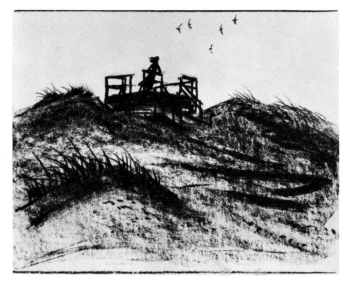

6. Color depth. Hot and warm colors have a tendency to move forward in a picture, while cool, very muted colors move backward. (See color illustrations.)

7. Points of view when depicting objects. A rectangular building represented from only one side reveals little depth; when represented with two sides or planes visible, it creates depth because its form is explained. This change of point of view can be applied with many natural and man-made forms to create visual depth. Illustration by Allan Jones.

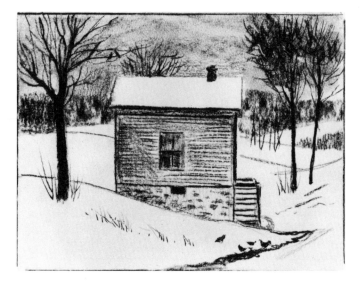

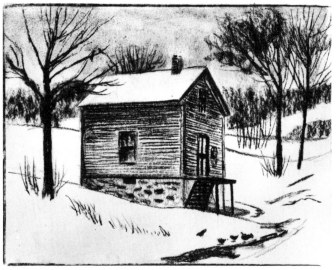

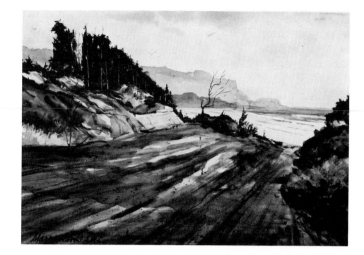

Right: *View of the Sea* by Marc Moon. Watercolor. Parallel lines moving into the picture point the viewer's eyes toward the distant sea. Moon's knowledge of perspective enables him to solve deep space problems like this one with realistic results.

Below: *Transformers and Trees* by Richard Porter. Acrylic polymer. This striking painting is a superb example of how depth and space can be created in a picture by overlapping shapes and by using contrasting tones which move from dark to light.

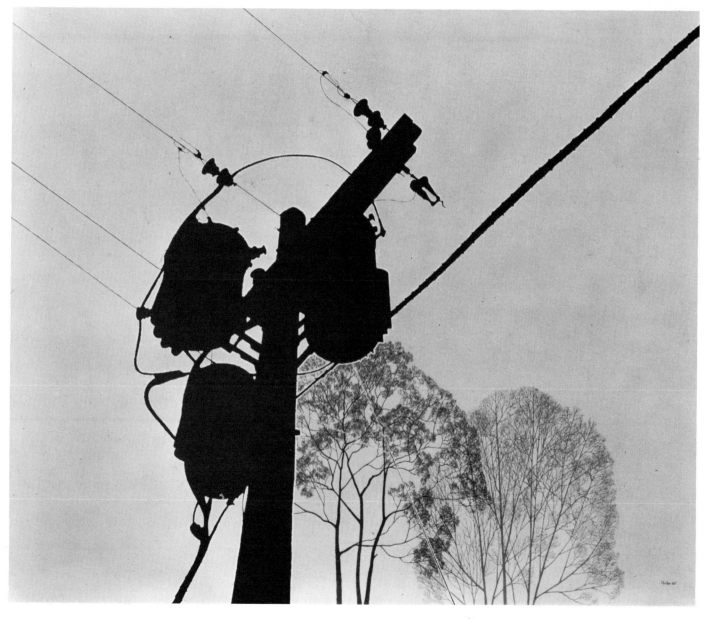

## Depth-Space Problems and How to Solve Them
### Illustrations by Allan Jones

1. Things go up in the air instead of back into the drawing or painting as you intended. Roads, streams and fields appear to be going uphill instead of into the picture. This problem can be solved by using your knowledge of what happens to parallel lines moving away from the viewer. Widen the portions of these shapes closest to the observer (generally the bottom or foreground of the picture) and make them get narrower as they move back. In other words, make the road wider close to you and make it smaller and smaller as it moves into the landscape away from you.

2. Large, flat, wide, empty expanses of land and water appear to rise up like walls instead of lying flat and receding. Flat shapes, belts, or area space divisions, which do not have objects on them or receding lines, appear to rise up like walls. Water can be made to appear still by using reflections, waves or ripples which get smaller and more indistinct as they recede. Shadows and/or tonal and color changes can often solve this problem. Grass and dirt textures can be represented more clearly. Emphasize them by making them larger in the foreground if that suits the character of the picture. Having these areas move from light to dark or dark to light can also improve the perspective. Making the colors cooler and more muted in the distance has a similar effect.

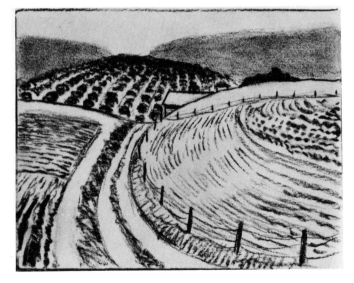

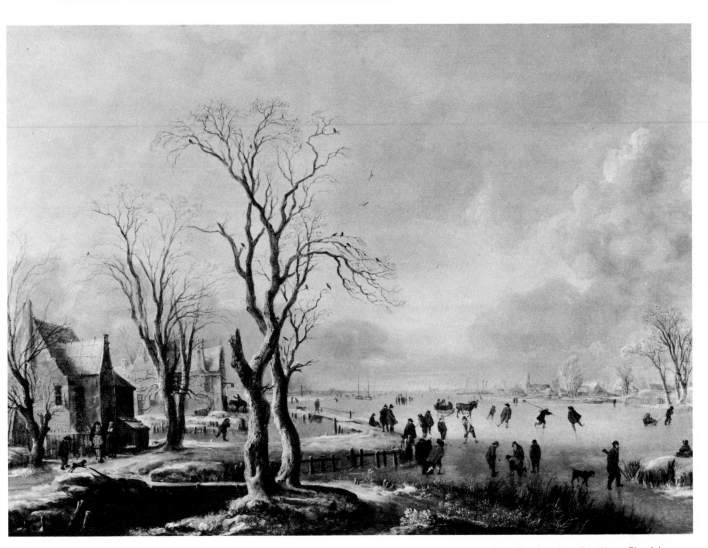

*Winter Sports on a Frozen Canal* by Aert Van Der Neer, Flemish 1603-1677. Courtesy of the Virginia Museum. Learning to show depth was an important part of an artist's training at this time in history and many interpreted their natural environment and their relationship to it through paintings that emphasized strong form and deep space.

Suggested Experiments in Perspective

1. Take a trip to view perspective or to sketch or paint. Learn to see what happens when subjects and areas are viewed from different levels. Notice how objects get smaller as they recede into the distance. Also, observe how parallel lines converge and tones and colors change. These results can be achieved in your pictures.

2. Observe the same subjects and the same scene from the three viewing levels and carefully note the changes in appearance of things. Lie or stoop down, stand up, and then if possible, climb up on something to observe. Which view depicts the deepest space? Which view flattens out the scene or makes it seem shallow?

3. Find examples of parallel lines, such as fence lines, roads, plowed fields and streams; study them from the three viewing levels. Get in a position where they are going away from you; then move to a position where they go directly across your line of vision from side to side.

4. Make sketches which depict deep space and depth. Use every means that you are acquainted with.

5. Try a sketch in which depth is created mainly by overlapping shapes and forms.

6. Use tone, soft- and hard-edge contours to create the illusion of depth.

7. Use color in one sketch or study. Try to create more depth by using warm and cool colors.

## Chapter Four

# You and Your Subject— Getting the Most from Both

If you have participated in the experiments and exercises in the preceding chapters in thinking, observing, drawing and painting, you have grown in skill as well as confidence. You have developed both thinking and working habits upon which to build and grow. You are working with an awareness of picture-building and composition and recognize the importance of design. At this stage it would be helpful to interpret your feelings about your subject and decide both what you want to say about it and how to put this across in the finished work. We will also examine various techniques of rendering that are appropriate for certain subjects and effects. A careful investigation of subjects offered in this section should lead you toward a mature approach to landscape painting so that you can get the most from yourself, your particular subject and the natural environment as a whole.

## What Do I Feel and How Do I Say It?

The original reasons one selects landscape or seascape painting as a means of creative expression vary, but a central reason is probably interest in the subject and love for it. Whether by intention or accident, an artist's works convey his attitudes about the subject. Analyzing your subject and your feelings can help you to become a more articulate interpreter.

Many beginners interpret "saying something about the subject" as implying a story, a moral statement, an allegorical or a symbolic representation. All of these interpretations and others like them are valid; nevertheless, saying something like "it's a grey and windy day" or "look at the sun on the sand dunes" can be in itself definitive and important.

If you are the type of person who sees a story in every blade of grass, try to organize your subject to convey the idea or story. It won't be that difficult because you have already thought of it in a particular way. At another time you might feel a special mood about a place because it recalls something from the past. This memory has already influenced how you see and feel, so let it come through.

Just feeling or reacting strongly towards a subject, however, does not guarantee that the resulting work of art will convey the same mood to the person who views it. Ask yourself, "What is it that I feel?" and "What do I know that can help me to express this in a picture?"

Top: *Summer Field* by author. Acrylic polymer on Upson board. Sharing an experience can be a valid reason for painting. Inviting the observer to see a subject through the artist's eyes can result in pictorial representations using a wide range of media, techniques, perspective and style. "Summer Field" invites you to experience this blossoming meadow by looking up at it from earth level.

*Gull and Dune* by author. Acrylic polymer on Upson board. Much of the meaning which is derived from a painting is read into it by the individual looking at it. Many times the artist painted the picture because he enjoyed recreating a subject, scene or experience which interested him and because he enjoyed using a particular medium.

Using what you know can carry you a long way toward accomplishing this goal.

The feeling we have about a subject or a scene is complex. It is usually a composite of feelings about the locale or related experiences. The painted picture does not convey all these feelings because the small section of the scene we have chosen to depict does not contain the essence of that total experience. You will achieve better results if you concentrate upon depicting the essence of the mood. Try to get to the essence of what moves you about the subject, what the subject is presenting or saying to you. It could fall into categories similar to these:

1. Story, moral or allegorical.
2. Mood, particular or general.
3. Interesting weather conditions or time of day.
4. Colors, textures, forms, shapes or compositional movements.
5. Interesting place or unusual subject matter.
6. Patterns of light and dark.
7. An idea for an abstract design.
8. An unusual or different perspective, or angle for viewing and representing nature.
9. Something which you think is beautiful and want to represent or recreate.

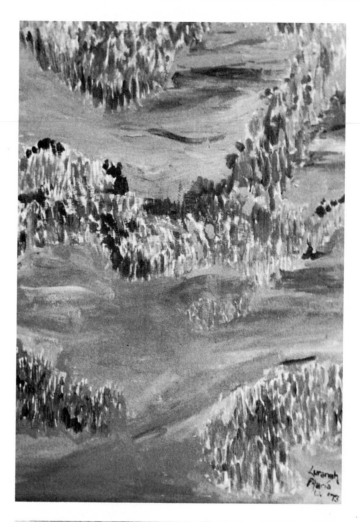

Right: *Landscape with Stream* by Leona Woody, age 9. Acrylic polymer on canvas. Daughter of artist Russell Woody. Children frequently are keen observers of the natural environment and enjoy expressing their reactions. This painting displays a remarkably mature approach to pictorial problem-solving and is bold and expressive in its use of paint.

Top: *Swamp* by Luranah Woody, age 12. Acrylic polymer. Daughter of artist Russell Woody. Freshness of paint application and the rendering of a definite mood characterize this study of a swamp.

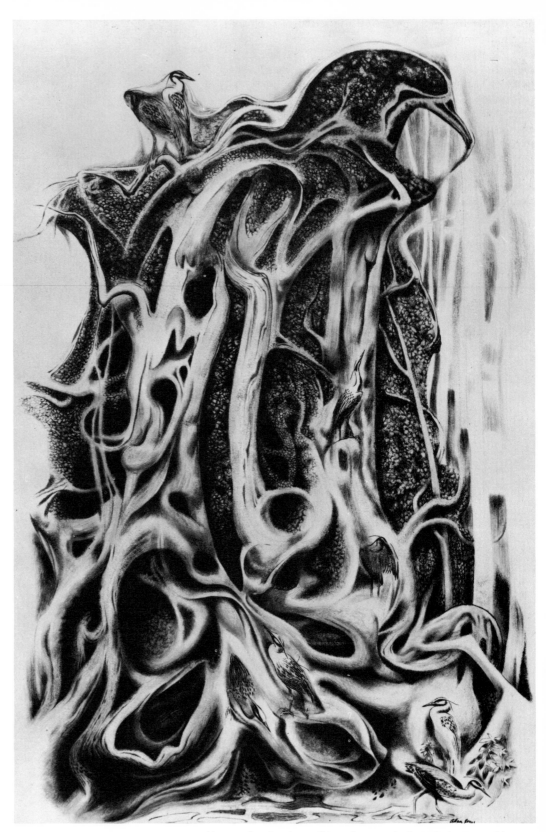

Nature often inspires artists to interpret it through dream world visions of surrealistic mystery and fantasy as demonstrated in this strange brush and ink drawing by Allan Jones.

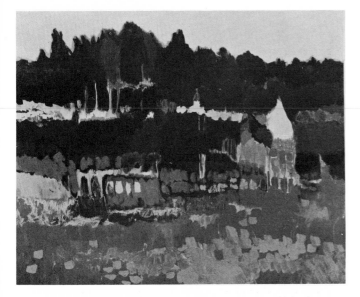

*Landscape* by Loraine Fink. Acrylic polymer on canvas. This vibrant painting sees nature in terms of distinctive shapes and patterns.

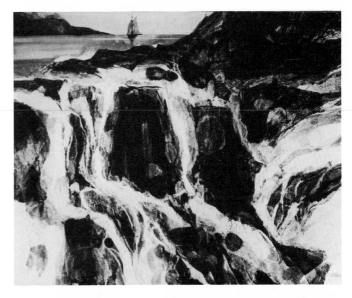

*Rocks and Coast* by Gerald F. Brommer. Water color and collage. Rocks can be stylized, working with their shapes and textures. Rice paper collage adds texture to both rocks and water.

*Farm with Windmill* by Clarence E. Kincaid. Watercolor on paper. Rich blending and bleeding of colors caused by applying watery washes of color to a wet working surface can be an effective method of expression if the artist is sensitive to the possibilities of the medium and has some familiarity with the discipline of using it. Kincaid's painting displays these qualities.

## The Natural Environment Through Media and Techniques

Many artists see the natural environment as suggesting the use of different techniques. Every different facet of nature invites them to use a different technique or media. A certain sky might lead the artist to use watercolor to represent it, while rugged stone cliffs might call for a relief painting done with a palette knife. This is an approach worthy of attention. Just ask the question, ''What media and technique do I know that would best capture the character and essence of this scene?'' Then try going at it with what strikes you as suitable.

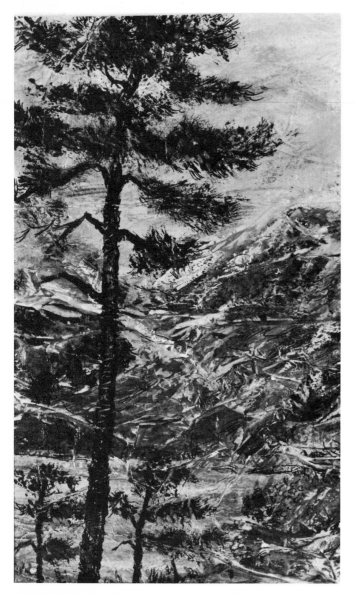

*Mountain Scape* by Florence Buchannan. Acrylic polymer collage. The crinkled paper in this collage helps depict the rock-like structure of the mountain.

## The Natural Environment as Seen Through Style

Style and technique are closely related. We think of technique as being the way materials are used, the manner in which objects are rendered, the particular method in which paint is applied, the pencil is blended or the ink is stroked onto the surface of the paper. Style is associated with the identifiable character and appearance of the whole picture. It is achieved by organizing and working in a particular way. Style can be classified in several ways: realistic, super-realistic, abstract, semi-abstract, impressionistic, surrealistic, romantic, classic, loose and free, tight and restrained, and so on. All of these terms say something about appearance and the manner in which it is achieved. Some of these terms may mean different things to different people or when used in different contexts. They are used here simply in a descriptive sense.

Some artists consciously employ a variety of styles to represent and interpret different aspects of nature. Still others see everything through one style and one kind of design. It is not the intent here to favor any single approach but to offer possibilities, to show what others have done and to then let the reader decide what is right for him by selection, trial, evaluation, modification and innovation.

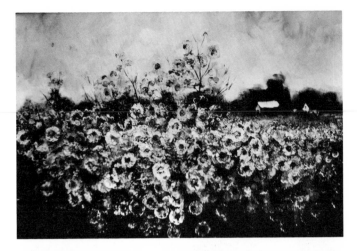

Top: *Daisy Field* by author. Acrylic polymer on Masonite panel. The daisy blossoms were created by stamping or printing them with daisy shapes cut from cardboard, dipped into paint and then repeatedly stamped onto the painting's surface.

Middle: *Plantation Totem* by author. Acrylic polymer on Masonite. A spraying technique was used to achieve the realistic clouds in the background.

Bottom: *Lakeside* by Joseph R. Morton. The impressionistic technique of applying paint in small brush strokes contributes to the vibrance of this luminous landscape.

*Windmill-Landscape Series* by Thomas Thorne. Historically, painting as a means of expression has undergone many stylistic changes. The same subject may be interpreted by several different artists. The similarities and differences are always interesting to compare. Rarely, if ever, do we see the same subject painted eight different times by the same artist intentionally using a different expressive style and utilizing different techniques. Dr. Thomas Thorne, Professor of Art at the College of William and Mary, created these unique and informative studies to help illustrate graphically the concept of style in painting. If we will think of painting style, in simplification, as a particular way or manner of saying something about a subject or as a way of looking at or viewing it, then we can understand that employing different styles enables the artist to say more easily what he feels about a subject. Each of Professor Thorne's paintings makes a unique statement, not possible to convey through any of the other interpretations. This series of paintings clearly points out that a knowledge of style and its implications can greatly broaden an artist's ability to express himself.

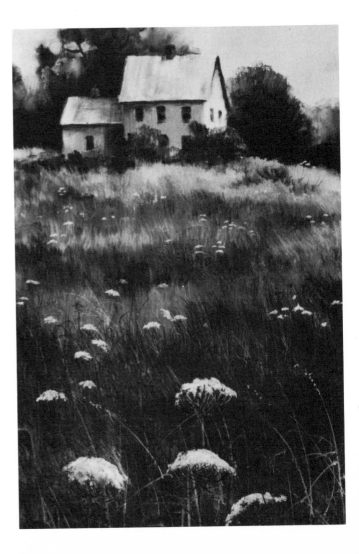

Above: *Ibex* by Frank Trozzo, student, Virginia Wesleyan College. Acrylic polymer on Masonite panel. This young artist has developed his own personal creative style. Although related to surrealism and other forms of fantastic and visionary art, his style has grown naturally out of his own philosophy, dreams and ideas.

Above right: *Children in a Landscape* by Lillian Rosenthall. Acrylic polymer. This visually distinctive painting is a representative example of the artist's style, brought about by a search for personal expression and much experimentation with various techniques of applying paints.

## The Shape of Your Vision

Many factors shape and influence the final form. These factors include composition, media, technique, style and personal interpretation. The choice of influential elements is, however, often left to chance: the size, shape and proportion of a particular work's pictorial space which is most frequently determined by the conveniently available stock sizes of paper, canvas and frames in the traditional proportions.

While one would be hard pressed to determine the exact feelings conveyed by each size, shape and proportion, we need only look and think a little to conclude that a tall, narrow, rectangular picture of autumn fields with a distant farmhouse is vastly different from the same scene depicted and composed in a square, or in a wide, narrow, horizontal rectangle.

***The Rectangle.*** Traditionally the rectangle has been the most used shape. Indeed, it is a versatile shape offering a wide variety of possibilities. Historically our psyches have been formed in relationship to this rectangular principle. Our whole sense of gravitational force and balance is dictated by it. Even pictorial compositions worked out for other shapes are basically controlled by awareness of the rectangle.

*Early Autumn* by author. Acrylic polymer on canvas. Owned by Mr. and Mrs. Norman Snead. A tall picture and wide picture of the same subject bring about different responses in the observer. An awareness of this factor can help the artist to be more articulate about his subject.

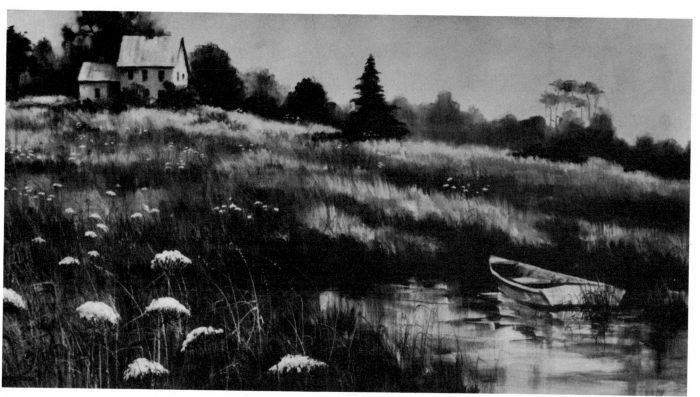

## The Circle and the Oval.

**The Circle and the Oval.** These shapes are interesting to use and offer refreshing variety in a picture world dominated by the rectangle. These shapes can accommodate most kinds of composition but especially lend themselves to the subject or object-dominated type. The rounded contours of the shape have a strong tendency to focus the viewer's attention toward the center of the picture.

*Spring Meadow* by Larry Knight. Acrylic polymer on illustration board. Painting a picture in an oval or a circle is no more difficult than composing one in other shapes. The same design considerations of dividing pictorial space and creating visual interest still apply.

These two sketches by the author, the round one done in line and acrylic wash and the rectangular one in lithograph crayon, show how the shape of a picture influences a composition. Notice how the boat in the foreground of the round study had to be foreshortened in its position because the space where it is located is narrower than the corresponding space in the rectangular picture. Other necessary variations appear in the two pictures.

*Free Form* by Thelma Akers. Acrylic polymer. This artist has experimented with freeform shapes. These abstractions often look like slices or slabs from nature. Organic in appearance, they seem to be derived from stones, cave formations and other natural forms.

***Free Forms and Other Shapes.*** In the past, whatever their shape, most pictures have been geometric and usually symmetrical. There are numerous reasons for this, most likely architectural and compositional, as well as philosophical. Tradition has kept the artist from exploring the possibilities for composition and creative expression offered by irregular, freeform and other shapes. Today, there are some who are experimenting with these shapes. Most of the works have been abstract or surrealistic. It is an area which offers challenging possibilities and could prove to be worth the time spent experimenting and investigating.

## Considerations of Proportion

***The Tall, Narrow, Vertical Picture.*** The narrow and vertical shape suggests a movement with upward and downward thrusts. For the landscape painter, it offers a pictorial space ideally suited to show the tallness and deepness of nature. Cliffs and trees can rise taller, birds can soar higher, waterfalls tumble farther and crevices appear deeper in a picture composed with an awareness of vertical qualities in both subject and shape.

***The Wide, Narrow, Horizontal Picture.*** The wide, narrow, horizontal picture can emphasize the breadth of things. Mountain ranges as well as flatlands and plains can show their wide expanse to advantage. Long waves can break, build and break again both close and far down the beach.

*Eastern Shore* by author. Lithograph crayon on paper. The tall, narrow, vertical picture is useful for emphasizing spatial depth. Tallness in a subject or great height can also be represented to advantage.

### The Square or Equally Proportioned Picture.
The square doesn't go anywhere on its own. Because it is as high as it is wide, its shape has no thrust. It has weight and presence, but on its own, it just sits there. Nevertheless, it is the most versatile shape and allows more compositional and pictorial possibilities than any other. It places the responsibility to do something interesting in the space on the artist. The square offers more opportunities for the display of deep space than any other shape. Lines can recede, shapes progress. They can move up, back, in, down and across; by contrast, in tall or wide shapes, they are restricted. In tall pictures, the main movement must be up and down, and in wide pictures, across.

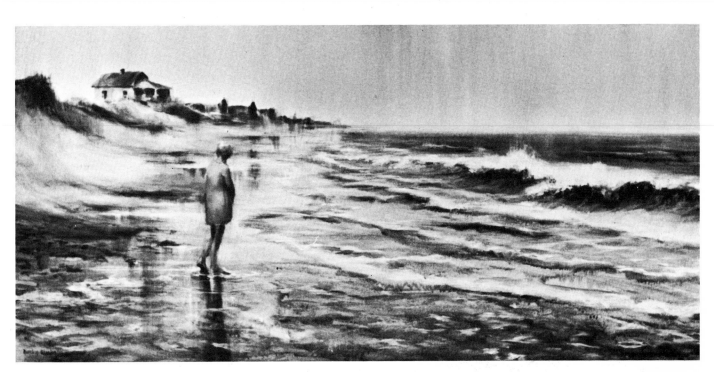

Above: *Day at the Beach* by author. Acrylic polymer on canvas. Courtesy of the Imperial Gallery, Virginia Beach. The wide, narrow horizontal picture is advantageous for subjects depicting certain kinds of spatial depth and distance such as the wide horizon, extended shore and the long lines of breaking surf.

Below: The square or equally proportioned picture is the most versatile as these two handsome watercolors by Marc Moon illustrate. The compositional and expressive possibilities of this shape have an almost unlimited scope.

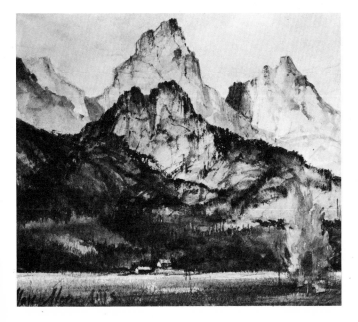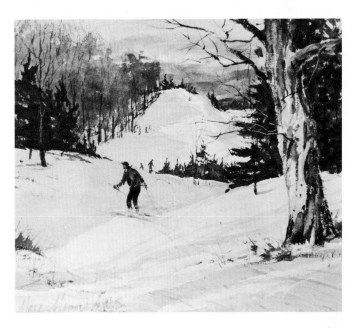

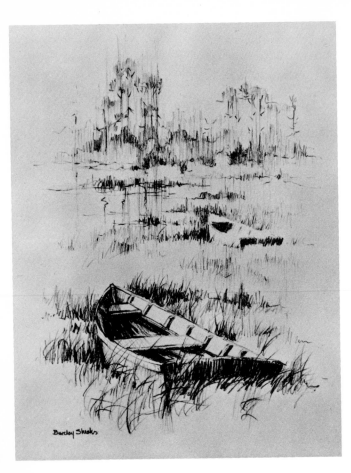

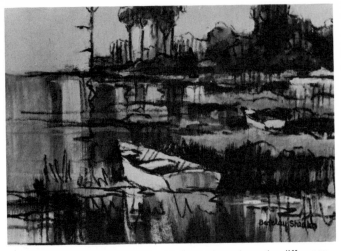

Two studies of the same subject by the author, show the difference in compositional arrangement, in appearance and in the feeling conveyed to the observer when the subject is adjusted to work harmoniously with the picture shape.

## Suggested Exercises in Shape and Proportion

1. Draw several circles and ovals on your sketch pad, then sketch pictures in them trying to use compositions which appear appropriate to you for these shapes.

2. Draw several irregular or freeform shapes and sketch pictures in them. Try to take advantage of the unusual and irregular contours of the shapes by using subjects or compositional movements which suit this space.

3. Draw three rectangles; one tall, narrow and vertical; one wide, narrow and horizontal; and one square. Sketch the same subject or picture in each of them. Make each picture emphasize the aspect of the subject that is most appropriate for the shape.

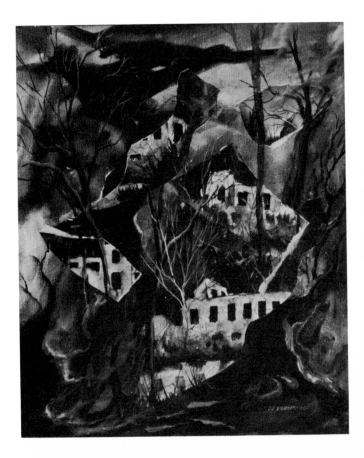

Right: Untitled watercolor and acrylic collage by Dixie Browning. A series of experiments led this artist to break up the conventional image of a painting by fragmenting it and redistributing its parts in an effort to emphasize the mood. A search for personal expression sometimes leads to the discovery of unconventional methods and techniques.

## Useful Techniques that can be Interesting and Appropriate

As an artist matures and gains broad experiences, he develops and masters basic techniques of rendering and of using various media. By experimenting and studying work done by other artists he also discovers certain special techniques and unique ways of working. Some of these discoveries may be very specialized and appropriate for representing very limited aspects of nature, while others are widely adaptable and versatile. A number of these techniques will be described here. Hopefully they will indicate the kind of relationships that can exist between the subject and the way it is rendered or described.

### Spraying

An airbrush or other paint sprayers can render clouds and create atmospheric effects in a realistic and super-real way which no other technique can equal.

### Spattering

Spattering, or flicking paint, is widely used by many artists for representing special textures, such as dirt, gravel and sand, and for creating visual interest in both simple and textured areas.

### Wet Blends

Soaking the working surface with water and then applying thin water color or acrylic washes, which run and bleed into the wet surface, is a popular technique—excellent for depicting clouds and skies. This is a standard watercolor method used on paper; it may also be done on canvas if acrylic paints are used.

### Dry Brushing

Dry brushing techniques are widely used in most painting media for creating textural effects and for depicting and simulating many natural textures, especially foliage, grass, wood grain, bushes, etc. Both stiff and soft bristle brushes may be used to apply the paint. Essentially, this technique involves dragging the nearly dried paint across the working surface with the brush. By varying the manner in which this is done and the kind of brush used with this technique, you can create an infinite variety of scumbles, tracks, marks and textures.

### Brush Slapping and Stippling

The slapping technique is related in method to the dry brush except that the side or edge of the brush is slapped against the working surface instead of dragged across it. In stippling, the brush is held upright and the paint is applied by punching the brush against the painting surface in a rapid manner. With a little practice, these methods can be used for rendering foliage, trees, bushes and related textural subjects.

### Glazing

Glazing can be an extremely effective procedure for creating luminous shadows and effects of light and depth. It can become an involved, complex process and its use is often misunderstood. Because of its great value when used properly, it is worth describing in brief.

Glazing is the application of transparent mixtures of oil or acrylic paint over areas and objects in the painting which are in a completed or partially completed state and are dry. These glazes are transparent, so they do not obliterate or block out the areas or objects; they only change the tones and colors creating unusual visual effects. For interesting color blendings, additional glazes of different colors may be applied on top of dried previously glazed areas. These mixtures are produced by mixing the appropriate oil or acrylic medium with the paints until the mixture becomes adequately transparent.

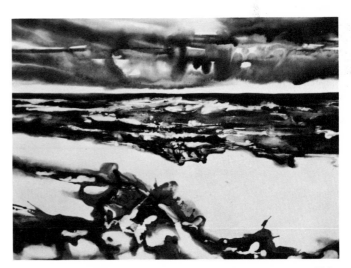

*Surf Study* by Russell O. Woody, Jr. Acrylic polymer on canvas. This forceful eight-foot seascape was created by using an unusual combination of techniques in which no brushes were employed. Thin mixtures of paint were poured onto the working surface and then manipulated by blowing air from a compressor.

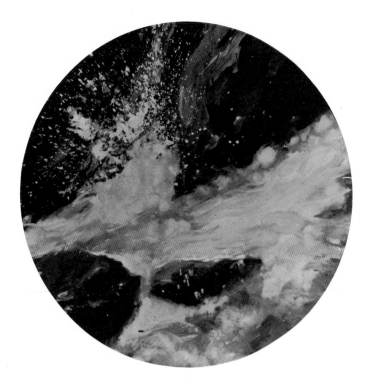

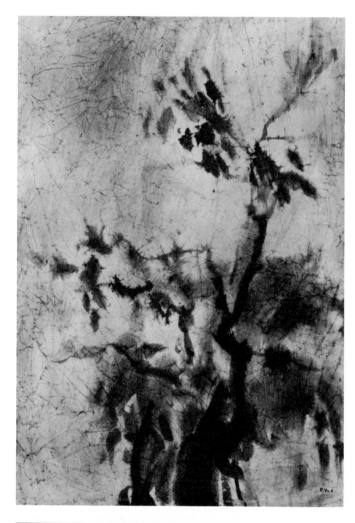

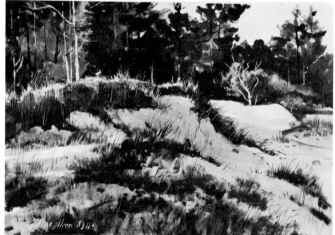

Above: *Cascade* by author. Acrylic polymer on illustration board. Spattering and flicking paint from a loaded brush to depict spray and splashing water is one of many uses of this method of paint application. It can also be used to represent sand, gravel and similar textural materials as well as blossoms and vegetation of various kinds.

Top right: *Blossoming Branch* by Robert Vick. Watercolor on rice paper. Wetting the working surface with water, then applying thin washes of paint onto this wet surface and allowing them to bleed and blend is a classic watercolor technique. Splendid use of this principle is demonstrated in this sensitive picture.

Right: *Bright Day* by Marc Moon. Watercolor on paper. Moon's use of the dry-brush techniques of paint application illustrates superbly the variety of use and versatility of this method.

## Additional Methods for Paint Application

There are numerous unconventional objects and devices suitable for applying paint and a variety of methods for using them. These can produce quite good effects if used properly. Sponges, wadded pieces of paper or cloth, pieces of carpet and other materials can be saturated with paint and pressed against the working surface or wiped across it, creating a variety of visual effects ranging from smooth blends to those which appear actively textural.

### Scraping, Wiping and Absorbing Wet Paint

The removal of freshly applied and wet paint can give distinctive results for certain appearances. While often associated with watercolor, this method is also applicable in oils and acrylics. In the scraping technique, the paint is scraped away, using a palette knife or a straight-edged tool of some kind. Whole areas may be pushed aside or removed—or fine and delicate lines may be inscribed. Wiping and absorbing is achieved by wiping and pressing absorbent materials, such as cloths and paper toweling, into the wet painted area exposing the undersurface.

### Scratching, Sanding and Removing Dried Paint

Interesting results are often achieved by sanding, scratching or scraping away dried applications of paint exposing the undersurface. This is most unusual and effective when several layers of different colors have been applied, one over the other, and allowed to dry. Thus, varied depths of scraping produce different colors.

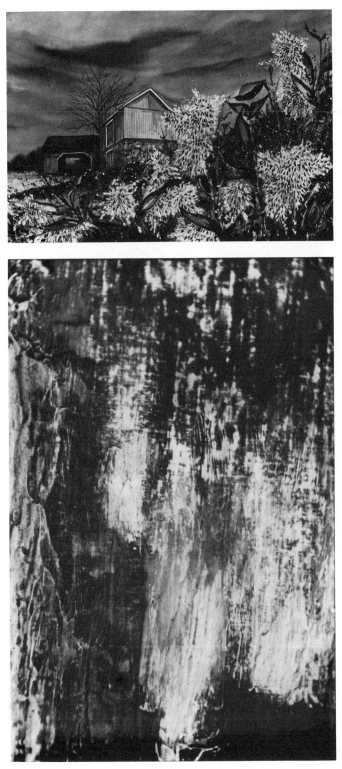

Top: Betty Zoe Miller makes effective use of several techniques in this handsome watercolor. Notice the wet blending in the sky and the use of spattering for the flowers in the foreground.

Above: Enlarged section of an abstract painting by artist Thelma Akers showing textural areas created by sanding and scraping.

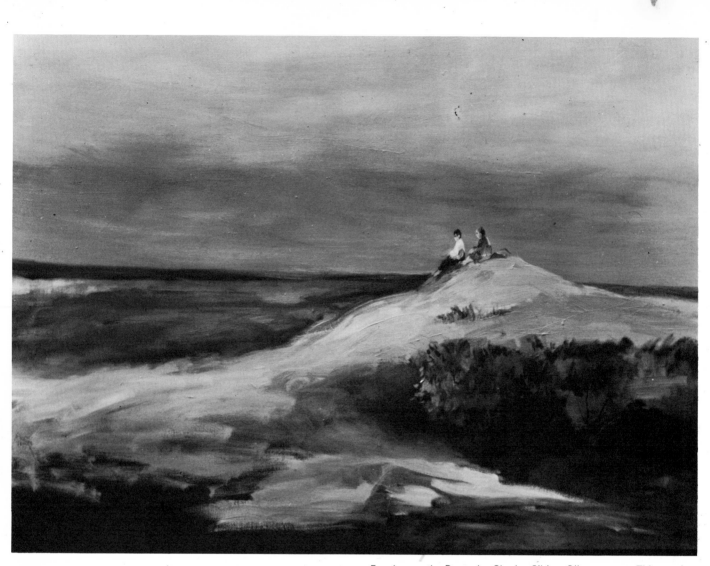

*Evening on the Dunes* by Charles Sibley. Oil on canvas. This poetic painting is a good example of a composition with a planned focal point. The linear thrusts of the horizon and the sweeping dune line lead the eye to the climax of the picture, the figures.

## Common Mistakes in Landscape Painting and How to Avoid Them

Hard and fast rules in art are difficult to make and there is an element of risk involved in attempting to state rules, since every one of them can be broken. Sometimes breaking the rules can contribute to the success of the completed work. There are some general rules, however, based on physical laws of vision which can help you avoid certain compositional problems such as awkward placement of objects, cramped space and movements which lead the eye too quickly or in the wrong direction. These compositional problems can make what would otherwise be a successful drawing or painting hard and unpleasant to look at. Most of the time these problems result from common but easily avoided mistakes. The drawings by Allan Jones that follow show some of them.

## The Bull's-Eye or Target

*Problem:* It is a natural, human tendency to place the main subject directly in or near the center of the picture, making it a direct, immediate focal point that attracts attention and makes looking at the rest of the picture difficult. This type of mistake is usually made worse by adding movements, such as fences, horizontal lines, roads, streams, etc., which lead the eye swiftly back to the subject before the rest of the picture can be studied and enjoyed.

*Solution:* Avoid the symmetrical placement of main subjects. Move them away from dead center. Have the other movements in the compositions lead the eye to the subject in an indirect manner.

## Squeezed Areas and Edges

*Problem:* When positive forms or objects are pushed almost together, a narrow, tight space is left between them. Tensions or pressures which destroy continuity of depth and space are created in these spaces. Attention is directed to these optically irritating places.

*Solution:* Have the forms within the picture touch and overlap slightly, or keep them separated by a clear space. Where objects and forms squeeze or end at the edges of the work, either run out the edge of the picture, where they will be cut off, or pull them back so that they remain within the picture by a reasonably comfortable margin.

 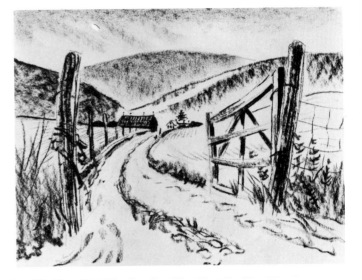

### The Non-Focal Point

*Problem:* Every drawing or painting does not need a focal point. Pictures which need focal points but do not have them present problems. Many times a series of lines or compositional thrusts will direct the eye to a portion of the picture where there is nothing of interest to reward the vision.

*Solution:* Analyze the compositional movements and organize or reorganize them so that the movements do not lead you to an uninteresting area and leave you there. Either make that dull area rewarding by adding extra color, tone, or texture or place an interesting object there. If you do not choose to solve it that way, have the compositional movements direct the eye around and through the composition to an area or subject that is interesting.

### Sacrificing the Whole for the Particular

*Problem:* As mentioned earlier, the dedicated nature lover sometimes studies and paints each area and object separately in isolation and without concern for the whole picture or without thinking of the total effect of all aspects of the picture and their relationships to each other. Each section may be rendered to perfection yet be canceled out by the area or object next to it.

*Solution:* The solution to this problem is very simple. Remind yourself constantly to keep aware of the total effect, the coordinated, related whole. Do this and you will not give equal emphasis to each object, or render one part of the drawing or painting in one style one day and another part in a different style the next.

## Coinciding Lines and Shapes

*Problem:* All factors in the composition may appear to be successfully arranged and coordinated. The tone and color work properly; the linear thrusts are balanced and harmonious. But if the picture is plagued with the unfortunate coinciding of lines and shapes, the resulting confusion in space and depth, and in object depiction and identification, will blemish the total success. For example, the line of the mountain tops runs directly into the roof top of the farmhouse. The mast of the boat coincides or lines up with the trunk of the pine tree directly behind it on the shore. The limbs of two trees run directly together and appear as if two different trees possess one common, joining limb. These visual illusions occur in nature frequently, depending upon the viewing angle of the observer, and are just as frequently repeated unthinkingly by the artist.

*Solution:* Study the picture and the subjects carefully, arrange the objects and shapes and control the lines so that they do not coincide. Raise either the mountains or the roof top so that they do not run together. Move the boat mast to one side or the other of the tree and raise or lower one of the limbs so that they do not appear to be one. A little observation will help prevent this problem before it becomes a blemish in your painting.

## Lack of Dominant Elements

*Problem:* The picture is frustratingly negative and uninteresting; one design factor cancels out or conflicts with another. The completed work lacks an identifiable character; it is discordant instead of harmonious.

*Solution:* The theory of domination or principal of dominant pictorial factors as introduced and illustrated with each of the major, basic design elements needs to be consciously applied in the picture if it is to be successful. Refer to the chapter on design to clarify these ideas if they are not fresh in your mind. Remember, a successful composition should have a dominant factor in each of the following: tone, color, and compositional movements or thrusts. Consistency of mood, technique and style is equally important.

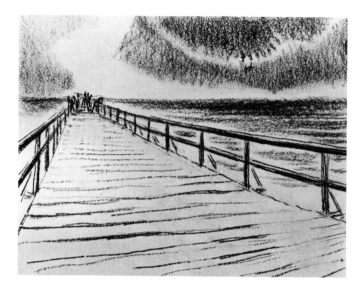

## Long, Unbroken Movements

*Problem:* Sometimes long, unbroken movements sweep our eyes too swiftly to a portion of the picture, or to the focal point, or even throughout an entire composition. Even though the picture in all other respects is satisfactory, the speed with which the vision sweeps along such long unbroken movements as roads, bodies of water, piers, fields, fence lines, and similar subjects keeps us from being able to linger and enjoy other aspects of the picture.

*Solution:* There are numerous devices which may be employed to slow down the visual movement. In a traditional landscape, shadows falling across the road will serve to break up the long movement and allow the eyes of the viewer to move to their destination at a leisurely pace. A sweeping horizontal line can be broken by having some object such as a tree or post rise through and above it. Softening parts of the long shape or form and blending or merging sections of its edge into the background is a method to be considered when others cannot be used or are not appropriate for a particular situation.

## Final Words of Advice for the Traditional Land or Seascape Artist

There are many words or pat phrases which could be given to the eager student as well as to the accomplished and seasoned artist. The most important advice, however, is simple and can be reduced to these short statements: Set challenging goals; work hard; produce; keep sensitive feelings and an open mind; use what you know; seek new ideas and approaches; don't get discouraged; and above all, EVALUATE YOUR WORK and then work from these evaluations. Remember, no great works have been produced by thinking without doing.

Untitled watercolor by Mary Schinnerer, student, Lutheran High
School, Los Angeles, California. The problem of being directed too
quickly to a subject with long, unbroken lines is skillfully avoided
by having the road make a sharp turn before it reaches the church
and by breaking the rapid thrust of the road with cast shadows.

*Surf and Stumps* by author. Acrylic on paper. While this might be a recognizable picture to those familiar with the subject, the feeling of force and action is created by following the abstract visual laws of linear thrust. The predominant movements in this composition are strongly diagonal, causing this feeling of explosive action. One way of creating an abstraction from nature is to take a subject like this and to interpret it as pure abstract thrusts and motion.

## Chapter Five

# Abstractions from Nature—
# Another Kind of Vision

An abstract picture is an arrangement or composition using lines, shapes, forms, colors, tones, textures and patterns that are not recognizable as realistic objects or subjects. An abstract picture is often referred to as a design. Design is one of the most important things about abstract painting.

## Why Interpret Nature Abstractly?

Perhaps the first question many individuals ask regarding abstract interpretations is: Why would anyone want to do it? Why would a perfectly intelligent human being waste time and materials creating pictures in which there is nothing recognizable? And then they ask, "What is it good for?"

One reason people ask questions like this is that a great majority of people think of art as things or subjects, not in terms of abstractions or basic design factors. They see nature, and art, too, for that matter, as trees, sunsets, changing tides, pounding surf and life processes that influence and relate to man. They see it further as consisting of subjects to be studied, examined, dissected, analyzed and cataloged. There is nothing wrong in itself with this view of the natural environment. As with any single viewpoint, it is limited in what it can see, in what it can say and in what form of aesthetic, creative and enriching experience it can provide.

These same individuals, often without realizing it, do respond sensitively to the abstract qualities of nature. The thrill one derives from the pounding surf as it crashes against the rocks is related to rocks and water, of course, but the experience of dynamic power is the essence of this reaction. In terms of abstract design, this results from the strong movements and thrusts exploding against solid forms. Understood as a solid form, a rock is an abstract concept. Thus, one can readily see that a great part of the appreciation of nature is basically abstract. When a person responds to a lovely sunset he reacts to the color. Color is abstract and so is a bird in flight or any patterns of movement. Trees are shapes, forms and textures, tones, colors and lines, as well as botanical specimens. Therefore, it should be easy to understand how all of nature is just as much purely abstract as it is anything else. The artist who sees the natural environment abstractly and expresses his interpretations of it in this manner is simply creating through another kind of vision.

Imagine that you are on an outing. While hiking along, you notice a small stone. It attracts your attention and you examine it. You turn it over in your hand, feeling its rounded contours and hefting its weight. Right then, you are appreciating it, or knowing it, through its form and shape. It will be rough in some places and smooth in others. This is texture. The contrast is interesting and enjoyable. This is contrast or variance. Looking at it closely, you notice dark and light lines running across the entire surface; your eyes trace their pattern. The stone is dark brown with small flecks of green and blue. What caused the colors to form in this pattern? Without realizing it, you have used another kind of awareness or vision to experience this part of nature. Many artists, through their art work, are interested in sharing and expressing experiences of this kind through abstract expression.

*Surf and Rocks* by Vance Mitchell. Acrylic polymer. Force and action are created by diagonal thrusts exploding against solid forms.

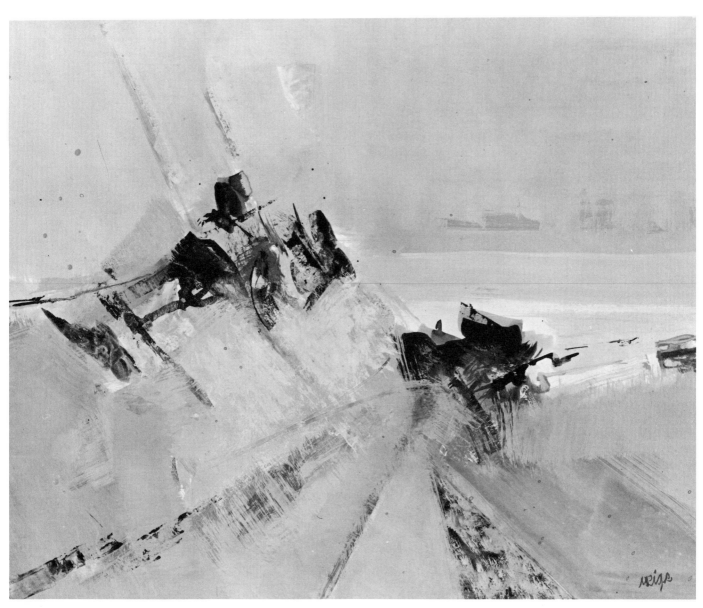

*Grey Dunes* by Walter Meigs. 1880-1946. Oil. Courtesy of the Virginia Museum. Meigs, one of America's first abstract painters, took movements suggested by observation of sand dunes and used them as a basis in creating this composition.

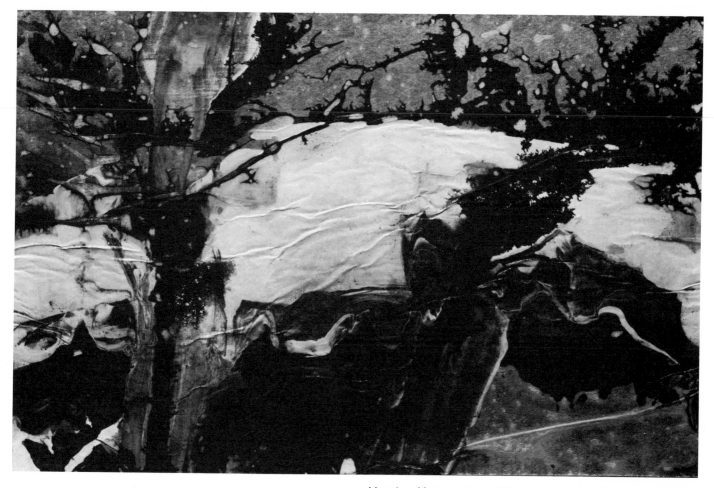

Mary Lou Moon creates exciting, nature inspired abstractions like this one by combining techniques of dripping, pouring, and spattering paint and ink upon a working surface of various kinds of folded and crinkled paper. She makes frequent use of metallic papers in this process.

## How to Interpret Nature Abstractly?

There are many inspirations for abstract art from nature along with methods and techniques of creating it. The main difference between the realistic and the abstract approach is in the appearance of the drawing or painting. As pictures, both kinds have to work, to be arranged and composed, to be visually interesting. Otherwise, they are not successful. They both deal with the same pictorial principles and problem-solving. In that respect they are the same.

To use nature as a source for abstract design think of nature as a resource for materials which the artist can use as points of departure, as inspirational starting points through which certain processes will emerge as abstract pictures. Two easily explained processes for doing this are dissecting and enlarging nature and using abstract patterns easily found in nature.

The realistic or traditional landscape painter comes to realize that few scenes or subjects exist in nature as perfect pictures. In order to be successful as art, the material has to be transformed, arranged and altered. The artist who interprets nature abstractly must realize this. He too must compose, change and alter for the sake of interest and good design.

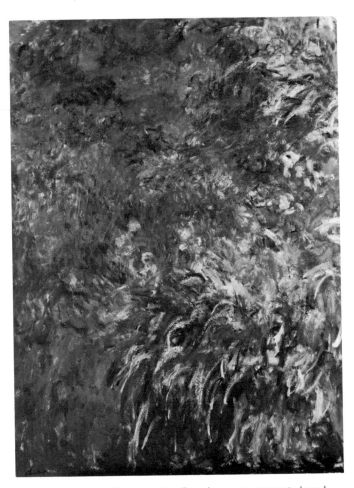

Left: *Phases* by Jack Fretwell. Acrylic polymer on corrugated cardboard. The phases of the moon underlay the creation of this inventive abstraction.

Above: *Iris by the Pond* by Claude Monet. Oil on canvas. French—painted around 1920. Courtesy of the Virginia Museum. While the subject was taken directly from nature, the process of enlarging and breaking it up into swirling impressionistic strokes and spots turned it into an abstraction.

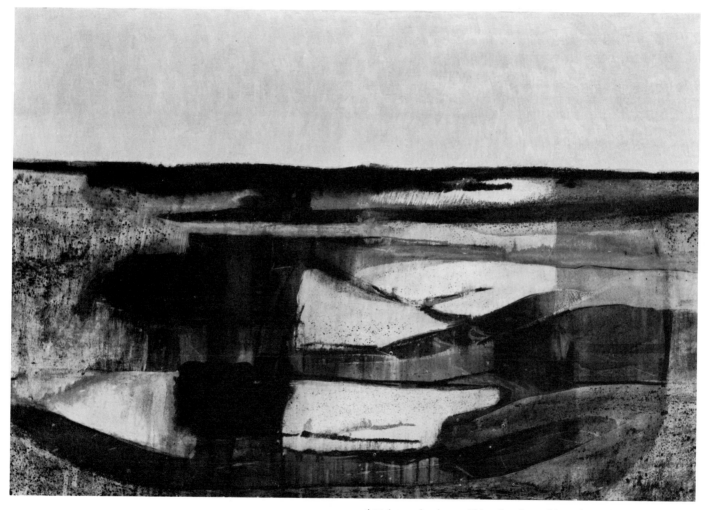

*Landscape* by James Kirby. Acrylic on Masonite. This striking
abstraction was composed by making use of earth textures, patterns
and contours of rock formations and land masses.

## Dissecting and Enlarging Nature

For the person oriented toward realistic subject matter, this offers an easy entrance into abstract painting. To dissect means to cut into sections and to enlarge means to make larger or focus upon. Creating a picture this way means to cut away a small section of an object or any part of the natural environment, isolate it and then enlarge it into a picture.

This does not mean selecting one tree from the forest to study. That would result in just another realistic picture. It means, for example, finding an area of foliage which, when sectioned off and focused upon, looks basically abstract, perhaps reminiscent of leaves. It could mean finding an interesting section of the tree trunk which, when greatly enlarged, would become a series of furrowed and trenched abstract forms—deeply modeled and shadowed. It could be selecting an interesting three- or four-inch section of a river bank and enlarging it into a three-foot painting in which the tiny grains of sand, colored pebbles and pieces of dirt lose their identity by being enlarged and changed into an interesting abstract pattern. The following illustrates further the varieties of subjects that easily lend themselves to this method:

1. A fragment of a reflection in the water.
2. A greatly enlarged section of foam from a wave, waterfall or stream of rushing water.
3. An enlarged section selected from the surface of an interesting rock or stone.
4. Magnified surface sections and pieces of objects viewed through a microscope.
5. A place where two or three areas, shapes or forms meet, touch or overlap.

Enlarged section of tree bark showing pattern created by lights and darks and the linear design of its structure.

120

Left: Photograph of natural objects found on a beach. Abstractions can be made from these objects by dissecting and enlarging selected sections of the photograph.

Below: Textures and patterns like these made up of barnacles, worm-eaten wood and rusted metal can be easily incorporated into abstract design.

Photography can be a great help in learning to see nature in this way. A regular lens, if it will focus down to a foot or so, will be sufficient but a two- or three-power converter or a close-up lens will work even better. Simply looking through the lens and focusing on parts of areas or objects will greatly aid in learning to think and see. An enlarger can conveniently blow up small sections of nature for examination and pattern organization.

Cut a small rectangular window, about two inches long and one inch wide, in a sheet of paper. Move it around the surface of photographs of nature, either those you have taken yourself or good examples found in certain magazines. Look for interesting areas which, because of the isolation, are abstract.

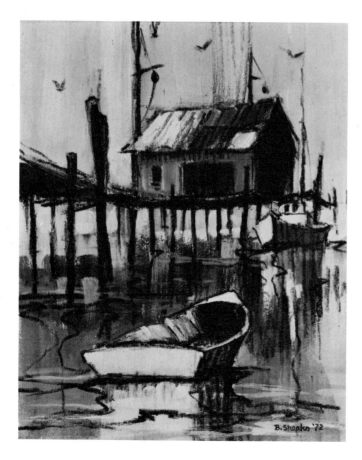

The three abstractions in this group of pictures were actually lifted from the realistic line and acrylic wash study of a fish house by photographing small sections of the picture and enlarging them. A little observation and study will make you aware of their respective locations in the picture. This dissecting and enlarging process can be a logical and effective way of abstracting.

Untitled. Oil on canvas by Jackie Merritt. Unfortunately, discarded remnants of man-made objects are ever present in the natural environment. Artist Merritt has created a handsome and inventive composition by dissecting and enlarging an arrangement of such materials.

Suggested Exercises in Dissecting and Enlarging

1. To become acquainted with how to make use of various basic design factors by abstracting, create four different small pictures in color. Each picture will select one of these basic design elements to emphasize: line, shape, form and texture. In other words, you will use those sections of your subject which are dominated by the design factor you wish to illustrate. For example, to illustrate line, select a subject with many lines. The subject chosen to be dissected and enlarged for texture will have more texture than other elements and so on with the other examples.

2. Select two of the five examples suggested as possible subjects for abstracting and create black and white studies of them. Pen and ink, brush and ink or dark pencil on paper are good mediums for these.

3. If this particular method interests you, select one of the examples done in black and white (or a new subject if you wish) and create a large painting, using color. Make it at least thirty-six inches in one dimension, larger would be even better.

*Mountains* by Mary Ann Harman. Oil on canvas. Mountain shapes simplified into flat patterns and textured with glowing fragmented colors form the design of this attractive painting.

## Using Abstract Patterns Easily Found in Nature

The procedure is easy and logical because the patterns are already abstract. The artist seeks out those that are interesting and uses them as the main compositional elements in the picture.

Here we define pattern as a flat, two-dimensional arrangement of shapes. This definition could be amplified into a lengthy description, including the relationship of other elements of design to pattern. For the sake of simplicity, we will leave it as it is. It will provide a base around which to build the entire concept, fitting in other elements as the idea develops.

Shadow patterns from tree foliage cast on a masonry wall create interesting patterns.

Oyster shells lose their identity and turn into a patterned abstraction in this photograph from nature.

Left: Light and dark pattern formed by light reflecting from water trapped in small pockets in the sandy beach at low tide.

Below: Linear design and light and dark pattern from a section of weathered driftwood.

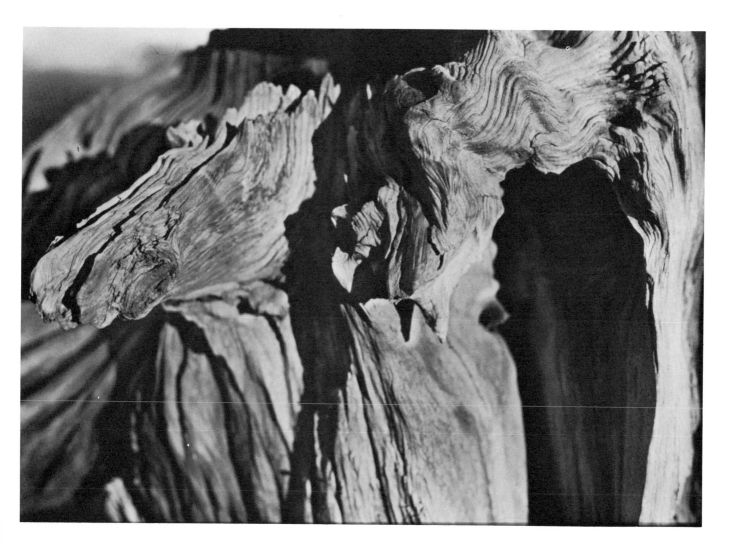

Nature provides all sorts of patterns, which are easily recognizable and essentially flat. Patterns of light and shadow provide good examples found everywhere in nature in an endless variety of shapes. There are also patterns created by perspective and space. When viewed from a high altitude or a great distance, fields, forests, shore and water turn into abstract shapes and colored patterns. These illustrations are offered simply as guides to understanding. The following list will describe the wide selection existing in the natural environment:

1. Patterns created by the forces of nature, such as those made by the wind in sand and snow, or the lines on the shore left by the ebbing tide.

2. Rippled patterns or reflections on the water.

3. Cloud patterns in the sky.

4. Surface markings and design patterns on natural objects, such as seashells, animals, seed pods, plants and flowers.

5. Spatter patterns created by liquids dropping on various surfaces.

6. Patterns arrived at by doing nature rubbings. (This process is described in the chapter on Design and Texture.)

Now that these patterns have been identified and their easy accessibility made clear, we may investigate the process of turning the design into a finished picture.

*Abstraction* by John Matheson. Acrylic on Masonite. The picture was tilted while the paint was being applied so it would to bleed and run into this abstraction reminiscent of sandbars and tidepools.

Untitled pencil drawing on paper by Jude Sibley, student, Virginia
Wesleyan College. This striking abstraction was created by stylizing
a pattern found in a textural rubbing.

## Making Pictures from Patterns

### Step One

You have discovered and selected an interesting pattern. Decide if the picture will be made up of hard-edged shapes or of shapes that have soft blended edges. You could combine the two. Nevertheless, for the sake of simplicity, in this exercise we will decide to place it in one or the other of these two categories. For this example, let us select hard-edged shapes.

### Step Two

Decide whether the pattern would be more visually effective and interesting if it were altered, if it had portions removed or added. Check for cramped areas of space. If the pattern's shapes are too scattered or spotty, tie them together with lines or have the shapes join or overlap to achieve unity. Change the drawing if it needs adjusting, or draw a new one. Now transfer the design to the canvas or another working surface.

### Step Three

Decide about color. Refer to the chapter on color. Keeping in mind the tone and color principles necessary for a visually interesting picture, paint the design, taking care that the edges of the shapes be sharp and clean. Keep the areas of color flat.

### Step Four

Study the picture. Decide whether you are going to leave it as a flat pattern picture. If the colors and tones are exciting, it might work best this way. If you decide on a flat pattern, adjust whichever colors or tones are needed, clean up the edges and outlines, and you have completed an abstraction.

Virginia Peck, student, Virginia Wesleyan College, did the nature rubbing (above) by making an arrangement of leaves on a flat surface. She then placed a sheet of thin paper over this arrangement and rubbed the surface of the paper with the edge of a black crayon, creating this graphic impression of the leaves. After studying the design of the rubbing, she transposed it into the interesting hard-edged, flat patterned painting (opposite) using acrylic polymer on canvas.

Joyce Brewster, student, Virginia Wesleyan College, used the nature rubbing of leaves (left) as a basic structure pattern for creating the abstract acrylic painting above.

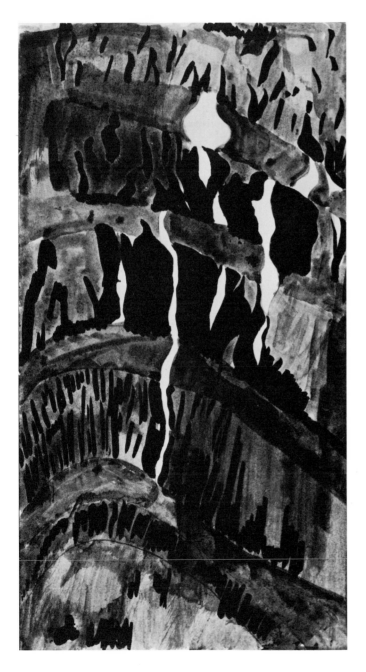

Alternate Decisions for Step Four

If you should want to carry the painting further for a different appearance which emphasize other aspects of design, here are the courses of action to follow:

1. For interest, you may add tone and color variance to the pattern by lightening and darkening areas within the same shape.

2. You could add form to the pattern, making it appear three-dimensional by adding lines or light and dark tones.

3. The picture might be improved by adding texture, either simulated and visual, or real and actual texture achieved by adding materials to the paint or by attaching with glue.

4. Your abstraction could be worked into a soft-edged painting by blending the edges of the shapes and by combining this approach with others previously mentioned, adding and building with the other design elements.

There are many other methods for and approaches to creating abstractions from nature. Some of them are subjective and intuitive, others logical and methodical. Still others may be arrived at by combining approaches. Both the semi-abstract and the visionary or surrealistic offer much material for invention and creative expression. Investigate and experiment.

*Study for an Abstract Painting* by Karen Heiberg, student, Virginia Wesleyan College. Ink on paper. This strong design was composed from patterns discovered in a nature rubbing.

Tree root

These three pictures illustrate a three-stage process used by Ann Halliday, student, Virginia Wesleyan College, to create a flat patterned, hard-edged painting from nature. The first stage (opposite) was made by a nature rubbing from a tree root. Stage two (left) consisted of making a sketch with a felt-tipped pen on paper. The elongated, figure-like shapes were suggested by the design of the nature rubbing. Stage three (below) is the completed painting done in acrylic polymer on canvas. Notice the changes in shapes and spacing, which give the painting more continuity, interesting spacing and a certain rhythmic flow lacking in the sketch.